Igbo Voices: advancing the Chi.

Uzoma Nwosu, MD

Igbo voices: advancing the Chi

(Advanced Igbo methods)

Igbo voices: advancing the Chi

Copyright © 2015 Uzoma Nwosu, MD

All rights reserved. No part of this book may be reproduced in any form, except by a newspaper or magazine reviewer who wishes to quote brief passages in connection with a review. Quotations of information should disclose the source of the information in this book. Copyright of this book is worldwide, in all languages. Editorial matters, sales and distribution rights should be addressed to Chiology 39 W 32nd Street, Suite 1502-3, NY, NY 10001. Email: info@chiology.org

Manufactured in the United States.

Library of Congress catalogue in-publication data. Nwosu, Uzoma Chika Nnadozie

Author: Uzoma Nwosu, MD

Igbo voices: advancing the Chi

Key Words: 1.Chi 2. Ikenga 3. Energy 4. Power.5. Breath 6. Movement 7. Courage 8. Ọfọ

This book is not intended to be used as a substitute for medical advice and treatment.

Always look up words you do not understand in a Standard English dictionary.

Igbo voices: advancing the Chi

Table of Contents

Igbo Voices: advancing the Chi. ... 1
Acknowledgements. .. 7
Foreword ... 9
Preface ... 10
Chiology .. 13
The Igbo .. 14
The Chi .. 16
 Chapter 1 Earth breathing (Umeana). 20
 Chapter 2 Desire ... 23
 Chapter 3 Uchechi (Thinking about the Chi) 30
 Chapter 4 The Ọfọ .. 33
 Chapter 5 The Palm Tree 37
 Chapter 6 Akuja (Security) 40
 Chapter 7 Ukaegbu .. 42
 Chapter 8 Laughter ... 48
 Chapter 9 Embrace Action 50
 Chapter 10 Touch .. 53
 Chapter 11 Courage .. 56
 Chapter 12 Dignity and Protection 58
 Chapter 13 Saying No ... 61

Chapter 14	Integrity	65
Chapter 15	Establishment	68
Chapter 16	Solution (Ọ́kpụkpara)	70
Chapter 17	Peace	73
Chapter 18	Create a way (Kezọ)	76
Chapter 19	Power, Strengths	78

Conclusion .. 82
The End ... 83
BIBLIOGRAPHY .. 84
Books and publications by the Author. 90
About the Author. .. 91
Index .. 92

Acknowledgements.

Many thanks to Michael Nwosu (Engr.), Dr. John E Nwosu, Chinua Achebe, Mbonu Ojike, Charles Thurstan Shaw, Catherine Acholonu, Michael B Daniels, Clive Swersky, and many other Igbo scholars who are just too many to mention.

DISCLAIMER: The use of 'names' in this work is for educational purposes only. These names are not intended to refer to any individual living or dead, except when clearly referring to a particular individual.

Foreword

'Igbo voices: advancing the Chi' deals with the Chi which is the 'personal god' of an individual. The Chi determines the destiny of that specific individual. This book is an important addition to the works of Chinua Achebe, Mbonu Ojike, and other Igbo literature icons.

The book describes how knowledge of the Chi can help an individual steer their life in the right direction that is based on love and happiness. I own an organization, Graceland Biotechnology Inc, that has recently introduced Obinaquine as topical treatment of Genital warts. I made the discovery, of the efficacy of Obinaquine, while working in my Hospital in Lagos, Nigeria. I noticed that a wart on the buttocks of a patient I injected with an anti-malarial agent had rapidly shrunk. My Chi was observant and vigilant (Chi mụ mụ anya). Today, based on my vigilance, we are able to make topical products that could be used against Genital warts, and other Human Papilloma Virus infections, including Cervical Cancer. Obinaquine cures genital warts with no re-infection, and confers active immunity to the host. Obinaquine is currently undergoing clinical evaluation in the United States and Asia. My Chi brought me fortune (Chiwetelụ ụba).

Our health is our first wealth. It is better to prepare and prevent rather than costly repair and repent. If we don't pay attention to our health now, then someday, our health will get our attention. In many cases it might be too late. Early detection of any kind of cancer saves lives. It is better to be poor and healthy than to be rich and sick. God heals and protects us from deadly diseases but it is the doctor that gets paid (smile).

A healthy person is known as 'onye ji azu eku ume' or a person who 'breathes with the back'. Back breathing is a relaxed type of

Igbo voices: advancing the Chi

breathing that is healthy and is a type of Umeana (breathing technique). These are the ancient practices that are associated with health and prosperity.

This book is not a medical textbook but is mainly for education and entertainment. I found it delighting and I believe you will find it delighting too.

Dr. Justice Emenike Obi, MD, RPh

Graceland Biotechnology Inc.

Motto: It is by acts and not by ideas that people live.

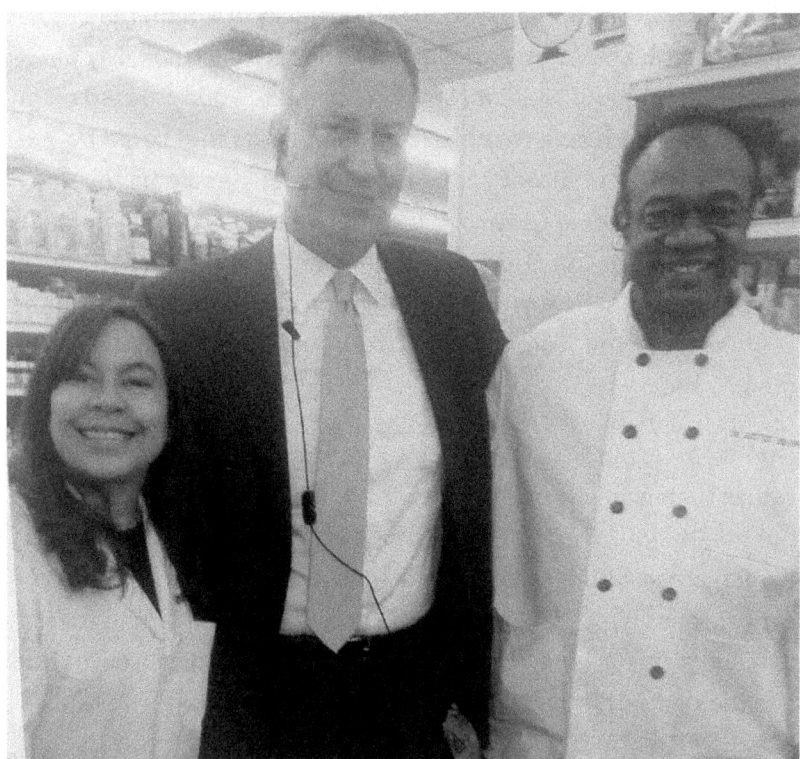

Dr. Obi with New York Mayor Bill de Blasio

Preface

Life is exciting and full of new adventures. In Igbo, the word for life (Ndụ) contains the verb 'dụ' which refers to 'being'. Everything that is alive has a way of 'being'. The 'being' of a person is projected from their Chi and helps determine their destiny, future, or outcomes. A 'crazy being' may end up in a Psychiatric Hospital. A peaceful and happy being is desirable and would have a hard time keeping up with all their friends. At the time of writing, a vengeful Chi from Maryland assassinated two NYPD (New York Police Department) cops and brought misfortune to himself and New Yorkers-the contents of the Chi determines the destiny of an Individual.

We live in a wonderful and active planet earth which has a cycle of life and death. Basically, energy is required to create and sustain life. Death is characterized by the inability to create energy. Every living thing continuously creates energy. Basically, to remain alive and well, a person must produce more energy than consumed. Oxygen in the air is converted into energy in the cell mitochondria. The utilization of glucose and other nutrients helps, and is necessary, for energy production. However, an individual cannot produce energy once oxygen supply has been cut off. The body has very limited reserves of oxygen and cannot handle any significant restriction of breathing. It is possible, that there are other planets with a higher concentration of oxygen, however, on earth, the oxygen concentration is about 20% and is even lower in higher altitudes.

This unique oxygen concentration and the body's inability to store oxygen makes this a notable planet for humans. In essence, humans have to adapt their breathing to the earth. This adaptation is known as 'Umeana' or Earth Breathing. Earth breathing, obviously, varies from person to person, but is the rate

of breathing that helps an individual with a specific 'being' that is necessary to achieve their objectives.

Voluntarily Regulated Breathing Practices (VRBPs) are a wide range of breathing practices that help individuals relax and ameliorate negative emotions such as anger, depression, frustration, etc. (Brown, Gerbarg and Muench, 2013). Earth Breathing (Umeana) is one of these practices.

In Igbo, there are respected elders known as Amana. An Amana is a statesman (Ojike, 1946). Amana contains the verbs 'ma' (to know) and 'ana'(earth) suggesting 'Earth knowledge'. Umeana (Earth breathing) is a practice that could help you have the being of an Amana (Earth Knowledge). In addition, there is a principle called Nanka from 'na' (go home/back) and nka(aging), which is basically 'anti-aging'. 'Earth breathing' is one of the VRBPs that could help an individual age gracefully with the right emotions. Nanka (anti-aging) could also be written as Anka- the prefix 'a' creates the negative of aging.

Hopefully, you will come to realize the Anka (anti-aging) properties of 'Earth Breathing' and the principles in this book.

Chiology

Chiology is the study of the Chi or 'energy summary' of an individual. It is based on the Igbo concept called the Chi which has been referred to as the 'personal god' of an individual (Ojike and Achebe). Chiology is performing a dual function: rehabilitating the ancient Igbo concept of the Chi, and also rehabilitating the Chi of individuals. The best way to conserve, preserve or rehabilitate a subject is to put it to daily use. A Chiologist is a student of the Chi. A Chiologist helps individuals rehabilitate their Chi. This is done by helping an individual 'rediscover' themselves and their purposes in life through embracing their energy and themselves. By eliminating negative emotions, an individual could focus and persist on their life purpose.

Chiology could be considered a spiritual town. In Igbo, a town is known as 'Obodo'. Obodo contains the verb 'bodo' which is 'bestow upon' (usually on the head). As a classic example, when an individual squats and a pot of water is loaded on their head, that action is 'bodo'. A town (obodo) places spiritual and physical concepts on the 'head' of an individual. New York bestows upon (places on the head) residents and visitors the opportunity to be successful. New York also places 'fashion and money' on the 'head' of visitors and residents alike. New York is widely regarded as the fashion capital of the world and because of the presence of Wall Street; it is acclaimed as the world's financial capital.

In Igbo land, different towns are known for different things. Nnewi people for instance, are known to be exceptional in commerce. Chief Cletus Ibeto of the Ibeto Group is from Nnewi. Chief Innocent Chukwuma who introduced the first made in Nigeria vehicles, Innoson VM, is also from Nnewi. Ordinarily, an Nnewi person is expected to strive for financial success. In

Igbo voices: advancing the Chi

Chiology, we placed 'defiance' to invalidation on your head, and in 'Igbo voices; advancing the Chi' we intend to add 'courage' to that.

NY is a favorite destination for those who seek love and fashion.

Igbo voices: advancing the Chi

The Igbo

Igbo is one of the three major tribes of Nigeria and produced Dr. Nnamdi Azikiwe and General Aguiyi-Ironsi, the first two Nigerian leaders. Chinua Achebe, Phillip Emeagwali, Chimanda Adichie, Pat Utomi and a host of others are Igbo.

Igbos suffered a disastrous setback following the failed secessionist state of Biafra. However, it is widely believed that the Igbos will make a comeback given the tenacity of the Igbo spirit. The tenacity is embedded in the language and culture of the Igbo.

The Igbos believe that every individual has a Chi that determines the destiny of that individual. In addition, they believe in God (Chi-ukwu) who is the Big Chi and the overall determinant of destiny. If an individual falls off a palm tree; it is the Chi. When an individual is killed by a drunk driver; it is understood that the Chi of the drunk driver, and possibly other Chi that influenced the drunk driver are involved. Ultimately, the Chi is responsible; in this case the 'Big Chi' is involved.

> **Important Notice:** The Igbo language is verb based. Actions were translated into verbs that are identified by their sound. There are some verbs that sound phonologically slightly different from each other. These verbs represent similar actions. The difference could be because the activities are performed in different environments, e.g. in the physical or spiritual planes. It can also be due to the presence of prefixes or suffixes that modify the sound of the verb. For example, the name Chika is from chi and ka. The 'i' in Chika sounds slightly phonologically different from the 'i' in Chi, but both convey the same message.
> Igbo is also polysemic-one word can have different meanings. For example, anụ could refer to animal, beast, fresh meat, cooked meat, or even a fool.

Igbo voices: advancing the Chi

The Chi

The Chi is a central topic in Igbo. The Chi of an individual could be summarized as the 'energy summary' of a person. The Chi determines destiny. If the Chi contains recklessness, an individual may end up in a motor vehicle accident. However, love and happiness in the Chi may lead to longevity and a worthy life.

Every individual has a spirit called 'mmụọ'. 'Mmụọ' contains the verb 'mụ' which refers to 'my soul' and to 'birth'. The soul gives 'birth' to the lives we live. A weak 'soul' gives birth to a 'weak' life. The body 'arụ' is a tool for operation in the physical universe. The soul is contained in the body (arụ mụ, body of my soul).

Ordinarily, the body is controlled by the soul. The spirit is not located in the physical plane, while the soul is in the body and controls the body through the specialized structure called the Chi. The Chi (energy summary) becomes problematic when it contains negative energy or emotions such as jealousy, revenge, hatred, and wickedness.

In Igbo, the Chi of a person determines the individual's destiny. The word destiny is from 'destination' and some people consider destiny the 'future'. The word chi also represents 'end' (uzoe**chi**na-let the road not **end**). The destiny of a person is like their 'end'. This is why someone could say, I ended up falling in love. In real terms, the Chi (energy summary) of a person creates their 'end' or 'destiny' in the present moment. Wherever you are right now is your 'end' and your Chi is responsible. The future, 'destiny', or 'end' is a series of 'ends' that occur in a series of 'now'.

Simply, the condition of a person's Chi determines their destiny. If a person's Chi is angry and they strike a police officer, they may

end up in jail. This is why a person must be in contact with their Chi.

The Chi(energy summary, destiny, end) of a person is determined by two principal factors-N**ch**ọ and U**ch**e. **Chi**, N**ch**ọ and U**ch**e contain the '**ch**' mother sound which describes 'ending', 'approximation' or 'destination'. Nchọ is a person's 'searching', 'desires' or 'wants'. A person's Nchọ activates the Chi. There is a very important board game known as Nchọ. In this game, players desire to reach four 'seeds' which is used to own a home. The word for four is 'anọ' which contains the verb 'nọ' which refers to 'togetherness'. The Nchọ (desire) of a person is seeking some type of 'togetherness'. A picture of a loving, happy family in a great home is an example of 'desire'. The word for home 'unọ' and welcome 'nnọọ' contain the same verb 'nọ' which is 'togetherness'. A home promotes 'welcoming' and 'togetherness'. In ancient times, the game 'Nchọ' was used to revive and rehabilitate a person's desire for 'togetherness'. Simply, have your family play 'Nchọ' repeatedly and watch their ability to pursue their desires improve.

Chief Moshood Abiola, the acclaimed winner of the June 12 Presidential elections, had a strong desire to rule Nigerian that was thwarted by the then military authorities. A strong desire is known as 'Nchọrikọ'.

Igbo voices: advancing the Chi

THIS IS AN IMPORTANT STARTING POINT.

The Nchọ (Nchọlọkọtọ)- the desire game.

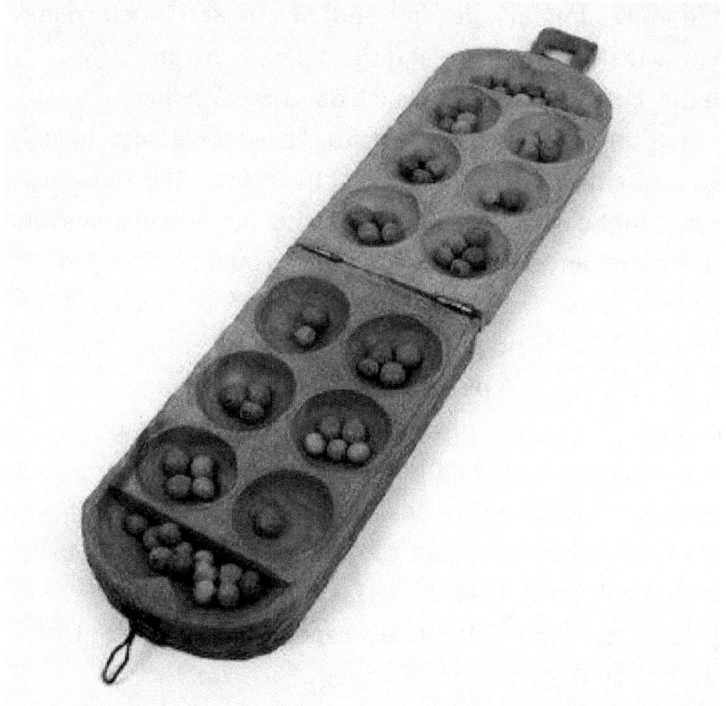

Uche is the word for 'thought' and contains the verb 'che' (waiting). Thoughts(uche) have to 'wait' for the 'Nchọ' or desire.

Desires, drive the thoughts. A positive desire leads to positive thoughts and vice versa. In Chiology, the main idea is to give a person the ability to continuously have positive desires. This is done mainly through Earth Breathing (umeana), Sky breathing (umigwe), and physical activity such as dance. These are some of the activities that eliminate negative emotions.

The Nchọ(desire) and Uche(thought) lead to our 'actions' known as 'ume'. To underscore the relationship between actions and breathing, the word for breathing is phonologically very similar

Igbo voices: advancing the Chi

and is 'ume'. Advanced Chiologists are naturally able to breathe into their actions. Our actions (ume) determine our habits or behavior known as 'omume'. Omume contains 'mụ'(my soul) and me(act) suggesting that habits are 'soul acts'. These 'soul acts' is the Chi, the destiny, future or end.

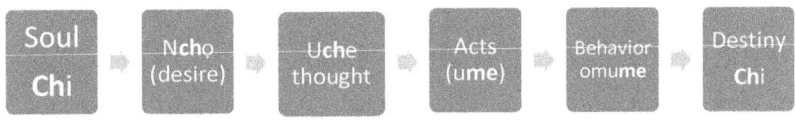

Desire, thoughts and action progression.

The Ọfọ (symbol of authority, Ojike,1946) is like a driving wheel that is used to balance the desires.

In Advanced Chiology, people are encouraged to have courage in the Chi. Without courage, the body will always cower and resist the direction of the spirit or soul. This is why in Christianity, it is written that without faith, it is impossible to please God. It is important to use wisdom and stand up to oppressors.

Chapter 1- Earth Breathing (Umeana).

Umeana is a state of mind characterized by healthy emotions such as peace, happiness, diligence, truthfulness, honesty, reliability, and other positive attributes. It can be considered in English as Earth Breathing. Umeana affects that 'heart', and a heart influenced by umeana is known as 'obi umeana'. A person with 'Obi umeana' (heart of Earth breathing) is highly desirable and are known to be gentle and undertake tasks with a high level of integrity.

Earth breathing (umeana) is a gentle and deep breath that is basically grounded in earth. It is the breath for the earth. A breath synchronized with the earth for someone who is on earth for service. It is a breathing pattern that is anchored in the reality of the earth.

In ancient Igbo, in addition to the Nze and Ozo Priests there were individuals in leadership positions known as Amana. An Amana settles disputes among the people and represents them in the Kings (Eze) palace. Amana contains 'ma' (to know) and 'ana'(earth). An Amana knows the way of the earth. The earth was not just Land, it was viewed as an authority by itself that is linked to human predecessors. Ordinarily, an Amana synchronizes himself with the earth, displaying the gentle but yet tough qualities of the earth. Obviously, patience and wisdom is required to lead a group of people. In order to maintain, a high level of discipline, an Amana knows Umeana (earth breathing), a very slow and gentle type of breathing that is relaxing and enables an individual connect to the masses. Earth breathing at about 5 breaths per minute for about 20 minutes a day has been validated by scientific methods to relax and energize an individual (Brown, Gerbarg and Muench, 2013). It is a responsible way of

eliminating negative emotions such as anger, frustration, aggression, antagonism, hatred, jealousy, and other related emotions. Umeana (Earth Breathing) helps an individual acquire the loving and gentle energy of the mother earth. Each breath transports oxygen to the cell mitochondria where it is converted into energy. Total disruption of energy flow, for example due to choking, for a few minutes results in death.

Umeana is best practiced while lying on the earth, but can be done in a sitting position or any other comfortable position. The breath is slow and deep and the diaphragm is engaged which can be confirmed by watching the belly expand during inspiration. The palm can be gently placed on the belly and diaphragmatic activity can be observed by hand movement. An easy way to get someone to breathe deeply is to ask a person to breathe into the back. Deep breathing causes the inhalation of more air into the lung.

Sky breathing (Umigwe) is a specialized way of relaxing and acquiring creativity. In Sky breathing, an individual (or group) practices conscious breathing while gazing at the sky. Slow, deep breaths are also taken as in Umeana (Earth Breathing).One of the best ways to practice Sky breathing is to lie on a mat (ute) while gazing at the sky. The word 'ute'(mat) contains the verb 'te' which refers to 'prolongation'. Lying on a mat and relaxing is thought to prolong life. This could be through better sleep which is known to ameliorate a wide range of conditions including heart diseases.

Sky breathing is part of the life of an advanced person. In the morning, the breath is synchronized with the sky. An individual could spend a few minutes synchronizing the breath to the rising sun. The same can be done at any time, at mid-day, sunset and especially at night. At night, conscious breathing while observing

the moon is recommended. This is especially powerful at full moon when the moons power is at its height.

One can also practice sky breathing using a video on youtube (Chiology Sky breathing).

Summary

Earth breathing and Sky breathing entails taking slow deep breaths that engage the diaphragm. Night fall (Chi i ji) and sunrise (Chi i fo) are related to a persons Chi (the internal control, energy summary). The outcome of a person's life is a function of how an individual plans their day and night.

Chapter 2 DESIRE

Anyone interested in the Chi and destiny must come to know the importance of desire (Nchọ). An advancement of destiny begins with our desires and the decisions taken (or choices made) to reach the desires. Basically, desires trigger a series of decisions that could take someone to the 'promise land' or to 'destruction'. The 'promise land' could be a trip to Starbucks with your four grandchildren. It could also be a villa overlooking the waters of Monte Carlo. It could also be an affordable house in rural South Carolina where you do not have to pay rent.

Now in order to make the right decisions or choices, one must be in the right mood. We are all aware of the dangers of making decisions in anger, frustration or vengeance. Adolf Hitler threw away a Great Germany by taking vengeful decisions. 'Earth Breathing' (Umeana) is a way to help reduce stress and negative emotions so an individual could take decisions in the right mood with the right and gentle energy.

Basically, to regain an individual's destiny, we would try to rehabilitate their desire. A reckless driver who is always above the speed limit is 'desirous' of speed tickets and a visit to the hospital. Such a person may not be fully aware of their desires.

The game Nchọ (Nchọlọkọtọ) was designed to rehabilitate desire. This game is played by many African tribes and the variations and rules are listless (Uchendu, 1965). There are two or more players and it normally consists of six round holes on either side which are called unọ (home).

Igbo voices: advancing the Chi

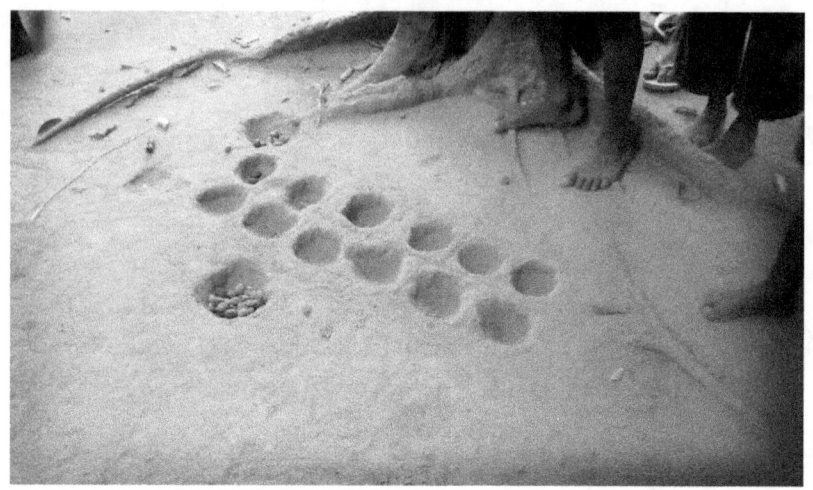

Hand-dug Nchọ in Iyora Anam, Nigeria. Image by DK Osseo-Asare.

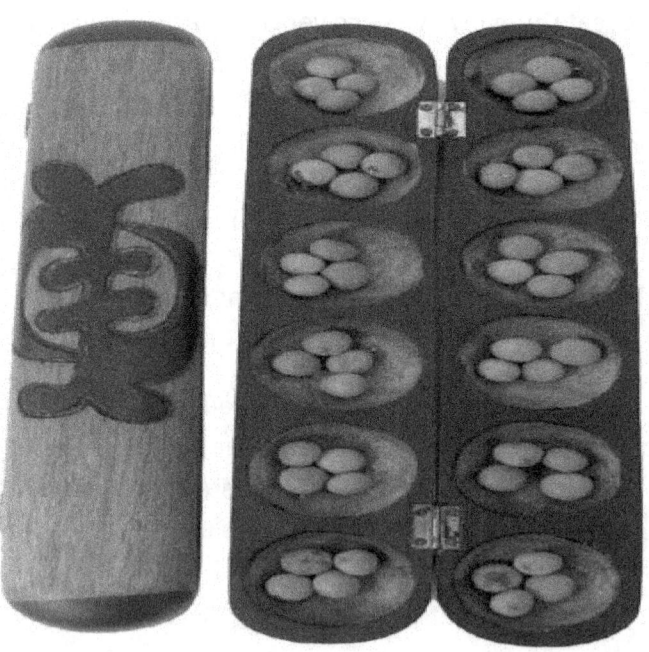

Nchọ (djembe.com)

Igbo voices: advancing the Chi

At the beginning of the game, each 'home' contains four seeds. These seeds could represent anything. For example, they could represent the earth (ana), wind (ikuku), fire (ọkụ) and water (mmiri) that were used to create the world. They could represent people or anything which players could agree on.

The winner of the game is the person with the biggest ability to put seeds in 'homes'. In other words, the winner is the person with the greatest ability to cause homes to be occupied or 'occupy able'. So, Nchọ rehabilitates the power to create. This power to create is 'rehabilitated' by 'rehabilitating' the desire to create homes.

Nchọlọkọtọ was derived from 'Nchọ','lọ', 'kọ' and 'tọ'. As mentioned earlier, Nchọ was derived from the verb chọ which is to 'search' or 'desire'. 'Lọ' is a verb that indicates to 'misdirect', 'indirect' or 'mis-manipulate'. It is used in the word for 'limping'. The verb 'tọ' is to 'drag' or 'seize' and is used in the word for kidnappers (Ndi ntọ). The verb 'kọ' indicates 'desirousness' and is used in the word for 'scarcity' and dry (e.g. clothing). In Nchọ (game), a player 'takes' seeds from homes and spreads them in an anti-clockwise fashion. Keeping it simple, Nchọlọkọtọ is 'desire swinging'.

The game starts with creation at its completion-all the homes are occupied with four seeds each. Play commences when a player picks the seeds in one home, from his/her home row, and spreads the seeds at a rate of one seed per successive home in an anti-clockwise manner. Empty homes are first created in this manner (by distributing the four seeds in one's home row). The last seed is combined with the contents of the last consecutive home, and the swinging continues-each 'home' getting one new seed. Play comes to a halt when a player lands in an empty home (with no seed). Empty 'homes' are created by 'last seeds' that were

combined with previous home contents or by a player distributing the contents of his/her own home row.

When play halts by the last seed landing in an empty home, the other player commences, carrying out the same anti-clock wise swinging. Homes are gradually repopulated with seeds and when a home row gets its four seeds back, they could be retired by taking them out of the hole (home) and holding them in a player seed 'pouch'. The game continues until the seeds on the board are exhausted. The winner is the person with the largest number of seeds. The seeds are used to repopulate the board. For example, in a two player game, one player could now have seven homes and the other person now has five 'homes'. Play continues and the winner has the most homes and the looser is homeless. Winning requires planning and tests a person's mathematical skills. Basically, it tests a person's ability to combine (seeds) in order to reach a desired outcome. It also illustrates the point that creation is combination. This is why the word to create 'ke' is also the word to 'combine' or 'string together'. As mentioned before, this game is rehabilitating a person's desire through rehabilitating the desire to create homes.

A homeless person is the looser. In Chiology, anyone who is renting or sharing an apartment is homeless. Winning is having a mortgage or property title in your name. Winning obviously requires planning and strategy that results in more homes in Nchọ (Desire game).

Rehabilitating the desire to create homes has practical implications. A successful individual who has many homes is obviously in a better position than a person with no or few homes. A village Chief with many homes in his compound is better off than a person with only one home. If one has one home, and it is destroyed by a sudden landslide (Mbuze) or a

storm, the person is done. However, a person with many homes can move into another home.

Nchọ (desire game) is designed to rehabilitate a person's ability and willingness to have more through mathematics, planning, strategy, etc. In order to make the best decisions, a person needs to be cool and calculated. Earth Breathing (Umeana) is designed to help a person achieve this.

Partnerships and creation

Ordinarily, in order to create, one would need to combine two or more items. Even if a person cuts their pants in half in order to make a new creation-the resulting material is still a product of two or more items by different measures. The fact that scissors were used already demonstrates that a combination is necessary.

In Nchọ(game), a player comes to a halt in an empty home(ụnọ). The player cannot advance because they have only one seed and that cannot be used in creation. The seeds could represent anything such as earth (ana), wind (ikuku), fire (ọkụ) and water (mmiri) that was used to create the world. The world was created by mixing these 'elements'. The seed could also represent people. A house occupied by one person is non-desirable. The word for two in Igbo is 'Ibụa' and contains the verb 'bụ' which is 'being'. Conservative Igbos only accepts gifts in pairs. They argue that life occurs in pairs-male and female. Humans have two breasts, two legs, and organs occur in pairs or in left and right halves. This underscores their belief that more than one is necessary for creation-e.g. the creation of children.

In real life, regardless of one's profession, two or more people are usually required for there to be 'life' in an activity. The word to

work together or partner with someone or a group is known as 'mmekọ'. Mme is 'to do' or 'act' and 'kọ' is 'desirousness'. 'Kọ' is used in the word for 'dry' because dry clothing is 'desirous'. It is also used in the word for scarcity or deficiency because that creates a 'desire'. Basically, 'mmekọ' (partnership) is making 'desire'. It is like creating a vacuum that creates desire. For example, the partnership(s) that created the Long Island Expressway into New York City automatically creates a desire for people to drive on that road. An ugly man who is 'not so desirable', all of a sudden becomes 'desirable' because he got married and partnered with a woman. In Chiology, we hope to partner with you to increase the desire for knowledge of the Chi.

Partnership is an exchange of gifts from two or more Chi. Gifts come from the Chi (Chinenye) and gifts are given by a Chi (Chinenye).

Giving and partnership.

Summary

Desire is an important starting point for someone who plans to be the cause of their destiny. The desire which a person harbors has to be known or pictured. Example, a big house with a lovely wife and kids with a large swimming pool and large play ground for kids in a suburb. In order to reach the desire or destiny, decisions or choices have to be made. Those decisions need to be made with a clear head, and not one colored by vengeance, anger, hate, rat race, or other negative emotions. Breathing techniques (Earth Breathing and/or Sky Breathing) is necessary to help individual's clear negative emotions and connect the breath to their actions.

Nice home that can trigger desire. Image-Daniel Schwen

Chapter 3- Uchechi (Thinking about the Chi)

In Africa, people are given names that identify with a concept, idea, principle, truth or fact. For example, the name 'Nwosu' is a son dedicated as a Priest (Ojike, 1946 & Dike, 2007). Uchechukwu is a name that conveys the idea of 'God thought'. We know that God is known in Igbo as Chukwu (Chi-ukwu, Big Chi), and that every person has a 'personal god' known as the Chi. The Chi determines the destiny of an individual. If the Chi of a person is angry and aggressive they could assault someone and that could lead to the misfortune of imprisonment. Many of the Igbo practices such as 'Umeana' (Earth Breathing) and 'Umigwe' (Sky Breathing) are intended to relieve anger and frustration so an individual can face their real life objectives.

Uchechi (Chi thought) is not just a passive process. It is also an active process that requires an individual to deliberate on the actions of the Chi in the community or the world at large. For example, a person might start deliberating on why Barrack Obama won the USA Presidential elections twice. What is in his Chi?

- What is other Chi doing with rice cultivation?
- What is other Chi doing with cement production and building construction?
- What is other Chi doing with racism around the world.
- What is other Chi doing with food production and ending hunger?
- What is other Chi doing with Health Care, which direction are they going?
- What is the Chi doing with the Church?
- What is the Chi doing in the community?

Igbo voices: advancing the Chi

- Which persons is the Big Chi raising-up in the community?
- What is the Chi doing in the family?
- What is the Chi like in a person's life?
- Etc
- Etc
- Etc

Because the thought of the Chi is basically good, the idea is to focus on the good things that are happening. The positive things need more attention. For example, the fact that the US has a President and a Justice Secretary of African descent deserves more attention than a story of a drunken cop that shot a kid.

The process of Uchechi (Chi thought) is best done in a group. The process starts with Earth Breathing for 20 minutes, then a leader makes suggestions about what the Chi is doing. The same process can be done using the principle of Uchechukwu(God thought). In this case a leader makes suggestions on what God is doing and participants dwell on it.

For example:

- What is the Big Chi doing with the global economy?
- What is the Big Chi doing with Electricity Generation?
- What is the Big Chi doing in Presidential elections?
- What is the Big Chi doing in human diseases?
- What is the Big Chi doing about HIV? (It was recently reported that the ability of HIV to cause AIDs has diminished).
- Etc, etc, etc

Summary

Uchechi is a very powerful procedure that enables an individual to start living in the real world by keeping 'Chi thought' in the mind at all times. You would want to avoid a Chi that is angry and spiteful and make friends with a person who is kind and loving. For example, it is good for me to focus on those who are interested in the Chi.

Chapter 4 The Ọ́fọ́

The Ọ́fọ́ is a symbol of authority (Ojike, 1946). Every house-hold had one, and it was taken to important meetings as a commitment to truth, justice and law.

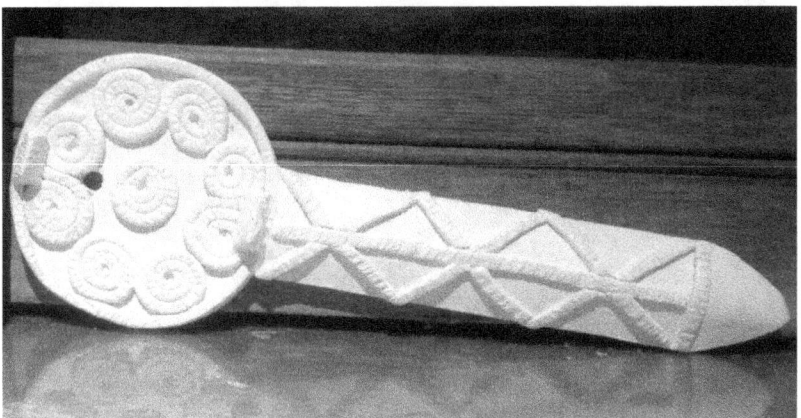

An ancient Ọ́fọ́-the 'opposing coils' represent balance and harmony. The 'double opposing coils' suggest motion, making this Ọ́fọ́ a life inanimate object. The 'x' represents the Chi.

The word 'Ọ́fọ́' contains the verb 'fọ' which refers to 'adequacy', 'sufficiency', or 'abundance'. Our Lord Jesus came that we have life, and have it abundantly (John 10, 10)- the Ọ́fọ́ was designed to give the Igbo and all people life, abundant life.

To be issued an Ọ́fọ́ is a privilege and an authorization to be a stand for the truth, justice and the law at all times (even under gun point). The Ọ́fọ́ was not issued to anybody. Recipients had to meet certain requirements that include age and status in the community. Before an Ọ́fọ́ is issued, the prospective recipient must profess to speak and stand by the truth at all times, and uphold justice and the law always.

Igbo voices: advancing the Chi

OFO-THE UNIVERSAL SYMBOL OF AUTHORITY

I_____
hereby commit to the truth, fairness and law.

_____ _____
Chiology Organization: Date Recipient Date

ỌFỌ CERTIFICATE

Igbo voices: advancing the Chi

It is not a minor problem to be caught in a lie while holding an Ófọ. To have life in abundance, an individual would need to have a high degree of integrity and respect for the law. We know that the Chi is the source of wealth or abundance (Chinwuba), so keeping the Chi in a good condition is necessary to hold an Ófọ.

Some of the 'emotions' that need to be in the Chi of an Ófọ holder include; integrity, fortitude, family, equanimity, generosity, responsibility, authenticity, happiness, community, possibility, positivity, beauty, creativity, electricity, equality, etc.

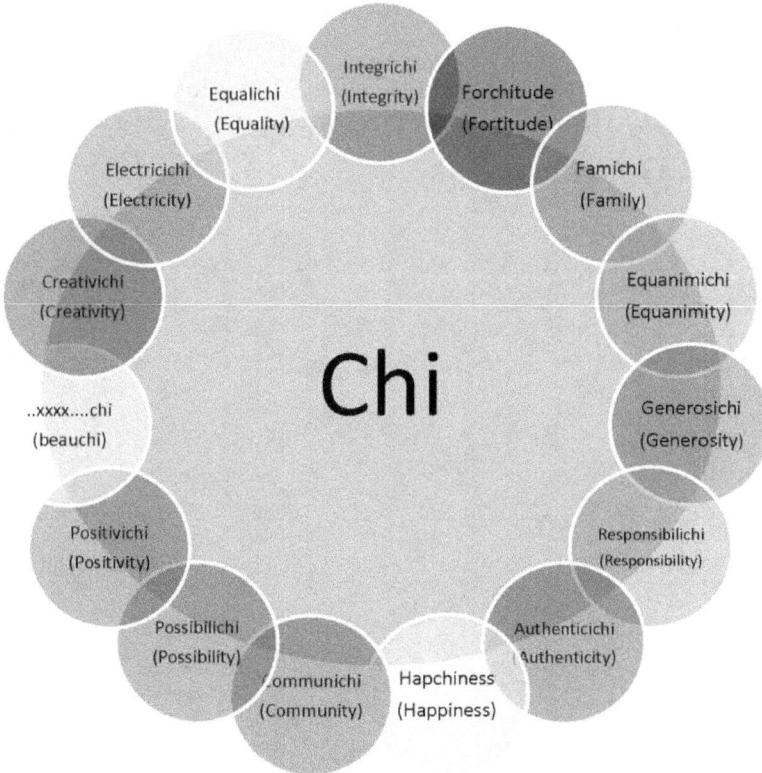

<u>Positive emotions in the Chi.</u>

Igbo voices: advancing the Chi

To ensure that positive emotions are dominant in a person's Chi, an individual needs to know Earth Breathing (Umeana). This can be done by listening to the 'Earth Breathing' vocal sounds that can be found in Amazon or itunes. For best results, practice about 20 minutes daily which can be spread out throughout the day. This can be enhanced by combining breathing with gentle movement or dance. On YouTube there is a video titled Chiology Sky Breathing that is also helpful.

Summary

To have abundance, it is good to make a commitment to truth, law and fairness. This is celebrated by owning and holding an Ọfọ which is a symbol of authority.

Chapter 5 The Palm Tree

The Palm tree is an extremely important tree to humanity and is sacred in Igbo. Without the palm, civilization may not have started.

The Palm. Image by Simon Sees.

To gauge the importance of the Palm tree:

- The palm is a symbol of victory, peace and fertility.
- It has the largest seeds and leaves of any plant.
- Without the Palm, expansion of humans into the arid and hot areas of the old world would have been highly restricted.
- The Palm is useful in agricultural production.
- Parts of the Palm can be used to make utensils.
- The Palm was mentioned more than thirty times in the Bible.

- Palm Oil, Palm wine, Coconut, dates, Sago, and heart of Palm, all come from Palm Trees.
- Palm logs were used to build Fort Moultrie and during the American Revolutionary War, the logs helped stop British cannon balls.
- Used to make cosmetics and food ingredients.
- Parts of the Palm can be used to make doormats, mattresses, ropes, brushes and similar goods.
- Parts of the Palm are used to make incense, varnishes and dyes.
- The Palm is a popular decoration for Parks and resorts.
- Symbol of victory and triumph in Roman times.
- The Palm is featured in the flags and seals of: Florida, South Carolina, Haiti, Guam and Samoa.
- In Christianity, the Palm was used to celebrate the triumphant entry of Jesus into Jerusalem-Palm Sunday.
- In Judaism the Palm represents plenty and peace.
- The palm is the tree of life in Kabbalah.
- Sacred tree of the Assyrians.
- Sacred sign of Apollo in ancient Greece.
- Parts of the Palm are used in furniture and building construction.

The Palm tree usually has a long stem that is often part of the forest canopy. This upright nature of the Palm, and its usefulness (food and accessories) makes it very important for symbolism. After all, what is the use of a plant that is not productive? In Igbo, there is a concept called Ogu. Ogu is often described together with the Ọfọ - Ogu na Ọfọ. Ogu is a twisted palm frond that represents innocence.

Ogu contains the verb 'gu' which is very tricky. To understand what they mean by 'gu', I would like you to imagine placing an upright umbrella next to a wall. That act is 'guzo'. Now 'guzo' contains the verbs 'gu' and 'zo'. To make it simple, the verb 'zo' indicates 'hiding'. By placing the umbrella against the wall, you have 'hidden' it somewhat. So the verb 'gu' most probably communicates 'uprightness' and guzo is 'upright hiding' or 'hiding upright'. Ogu is 'uprightness' or 'innocence'.

Now, ogu is made from 'twisted' palm fronds. Why did they choose the Palm? I suggest it is because the palm tree is very upright. It has this very upright stem and it is very versatile making edible fruits and nuts, and the leaves can be used in home construction. Expectedly, the palm tree is sacred in Igbo culture. The word upright contains 'up' and 'right' and is one of the English words with an Igbo mentality.

Now you can imagine they probably linked uprightness with 'production', 'ability' or 'goodness'. The word for the Palm, Nkwụ, contains the verb 'kwụ' which is stand-the palm is an example of how to stand and yield good fruit. So they want you to be upright like the Palm so you can produce abundance, and Ogu is the symbol. 'Earth breathing' and education can make a person upright so they can be productive.

Summary

Ogu is a twisted palm frond that represents innocence. The Palm tree is very productive making fruits that contain Palm oil. The kernel contains Palm Kernel Oil. Many parts of the palm are used in Agriculture, and in building and furniture construction. The Palm tree is very upright and this upright nature suggests that being upright is necessary to produce abundance.

Chapter 6 Akuja (Security)

Feeling secure is a requirement of Advanced Chiology. People who are insecure are easily frightened. They easily lose their composure. Sounds, voices, and movements could easily rattle them and they easily loose balance. Lack of composure is extremely important, because people are known to drop very expensive objects after being frightened.

People who are easily frightened are community targets. People are programmed to come after the weak and those that are easily frightened. In the wild, predators target the weak, especially when they are hungry. On the other hand, individuals who are secure are sought after by other individuals for friendship. They are not scared and usually end up in high places in the society. They are often associated with quality and reliable goods and services. No right minded person wants to deal with someone who is easily frightened. These individuals abuse the Police emergency numbers and can be readily observed online for their totally insecure and irrational points of view.

In Igbo, the word for 'fright' is known as 'Nkụja'. 'Nkụja' is from the words 'kụ'(break,smash) & 'ja'(communicate, rattle). An individual who is easily frightened has a problem receiving communication. Because they have a tendency to misinterpret communication, they tend to give off the wrong communication also. Effective communication with someone who is easily frightened is always a challenge. An easily frightened person could interpret; "..is your baby lively..?" as "is your baby dead..?". Before you know it, they are calling the baby sitter to find out if the baby is dead.

Igbo voices: advancing the Chi

In Chiology, it is understood that insecurity stems from past misunderstood and frightening communication that was never handled by the individual. For example, if someone was beaten up by a 'husky voice', one tends to be frightened by 'husky voices'.

To remedy the situation, self examination with a Chiologist is recommended. A Chiologist can guide you on how to become more balanced and centered, so you can receive communication with confidence. One common cause of insecurity is lack of knowledge. An individual who has little knowledge of the environment could be easily frightened. They are worried about surprises, and feel unable to handle surprises. In Chiology, we help people access conditions and situations in which they have been unable to handle satisfactorily. Lessons learnt from those specific situations could lead to more feelings of security.

In addition, insecure situations that cause doubt and worry should undergo a process called 'mgbagbu' (applied killing). In 'Mgbagbu' an individual eliminates the cause of doubts, worries and insecurities. This could be physical objects, persons (family members, friends, colleagues, etc) or places.

'Earth breathing' (umeana) is a Voluntarily Regulated Breathing Practice (VRBP) that can increase an individual's fortitude and help defeat feelings of insecurity.

Summary

Insecurity is an expression of a lack of confidence in receiving and giving communication in the environment. A barking dog is just a barking dog and does not mean a dog is trying to attack. 'Mgbagbu' (applied killing) is used to eliminate sources of worry, doubt and insecurity. Earth breathing helps eliminate the feelings of insecurity.

Chapter 7 Ukaegbu (Communicate wisely)

Ukaegbu suggests that conversation does not kill. In Igbo the tongue is known as Ile. Ile contains the verb 'le' which is 'manifest'. The words we speak can make or break us. We can create the lives of our choice by using the right words. In addition, our words can kill, especially the uneducated. In reality, human words are just sounds that do not have any inherent power. These sounds are converted into messages by conventions and agreements. The power of the spoken word is in these conventions and agreements.

For example, a Traffic cop could ask you to move your car. His/her words do not have any inherent power. However, the power of the Traffic cop's words lie in the fact that the society agrees that you can be issued a ticket that can be upheld by a Judge. If you fail to pay the ticket, your driving license can be revoked. The power in the cops words "..move your car.." lie in the conventions and agreements that can bring punitive damages if you fail to obey. This is why the Igbo word for Law is Iwu. Iwu contains the verb 'wu' which is pain, agony or misery. Violation of the law inherently brings pain, agony or misery. Iwu a ma go gi (you have violated the law) also means 'agony has known you'.

The same word could communicate entirely different messages over generations. For example, in South Africa a colored person is a mixed race person while in the United States, a colored person is a Black person. Words can kill an uneducated person who gives the word incredible powers in the Chi. People are known to freak out when called 'Nigger'. People are known to act stupid just because they were called 'stupid'. In Igbo, stupidity is known as 'Nsọkwu'. 'Nsọkwu' contains the words 'Nsọ' (reverence,

worship) and 'kwu' (speech). A father could tell a child, "I will take care of you" and the child now refuses to work, expecting the father to take care of him/her forever. These are cases of 'Nsọkwu'(word worship).

In Advanced Chiology, a person is expected to freely communicate without fear. Negative communication should not adversely affect an individual. An individual could list the worst communication they have received and practice being ok with them. The idea is to have a spirit that is strong enough to withstand all types of communication, especially abusive communication. Some individuals are in jail because they were verbally disrespected by others; that is 'Nsọkwu' or 'reverence of words'.

In Advanced Chiology, one is also encouraged to speak up because words should not kill. Words are just words and are for two way communication. The word for Church is known as Uka because the Church or a house of worship is a place of communication. 'Uka' contains the verb 'ka' which suggests 'communication'.

The mouth is not just an organ for kissing, speaking and feeding. The mouth can be used to make communicative gestures. Perhaps the most important aspect of communication is listening. Effective communication comes from listening and duplicating another person's communication. Ọnụ, the word for mouth, contains the verb 'nụ' which is 'listen'. In ancient times, the mouth was considered a listening tool. Often, we do not 'listen' to others because we do not listen with our 'mouths'. This is done by listening with the 'mouth' in a gesture of listening. It is also important to listen to what we are saying. Often we use words that we normally wouldn't have used, if we had been listening to what we say.

Igbo voices: advancing the Chi

The Okoso

Mature people understand that communication requires tact and skill. Effective communication requires making an assessment of the mood of the person you are communicating with. An angry person is extremely difficult to communicate with. You might as well be talking to a hand. The Igbo word for anger 'iwe' contains the verb 'we' which is withdrawal. Basically, a very angry person is not available for communication. A person who is angry and vengeful who wants to overthrow the government will not readily change the topic to that of a holiday in Cancun, Mexico.

The Okoso is a game played commonly among young boys. It involves snapping the Okoso with the thumb and middle finger. Once snapped, the Okoso starts spinning on the ground. The goal is to use the index finger to 'invert' the Okoso so that it ends upside down on its wide side, rather than on its side. The winner is the person first able to achieve ten 'inversions', and the reward is determined by the players.

An experienced player never tries to 'invert' the Okoso when its newly snapped and highly energetic. The idea is to wait, wait, wait, and wait until the Okoso begins to weaken. As the Okoso begins to dance and dance in this weakened state, at the right time, the player then manipulates the Okoso with the index finger in order to 'floor' or 'invert' it. So, the Okoso is like a communication lesson, there is a right time to deliver the communication to achieve the desired result. Being thoughtful (uche) contains the verb 'che' which is waiting, revealing some type of ingenuity with the Igbo use of words. Okoso contains the verbs 'ko' which is 'to draw' which is used in the word for cup 'iko'-the cup is used to draw water. The verb 'so' is to follow and is used in the word for nearby 'nọnso'. (Nọnso /nearby actually means 'together following' or 'following together'). So Okoso is

suggesting 'follow and draw'. Follow suggests staying in communication with the Okoso, and draw is delivering the 'inverting' communication with the index finger.

Okoso basically trains young boys to listen to the Okoso and then deliver communication at the right time to achieve the desired results. The Okoso spends a considerable amount of time spinning and dancing which suggests that we should have a highly developed sense of listening and waiting.

Some of the lesson from the Okoso:

- Patience is a virtue.
- Timing is important.
- You can invert an object with a little help.
- Something that seems impossible can be done easily with some help, patience, and right timing.
- Nothing is impossible.
- Energy can be transferred from the body to the Okoso by snapping.
- Snapping contains a sizeable amount of energy.
- You are unlikely to succeed in inverting a newly snapped and highly energetic Okoso. This applies to human relations as well, it is better to wait for people to cool down before communicating with them especially when they are angry.

Igbo voices: advancing the Chi

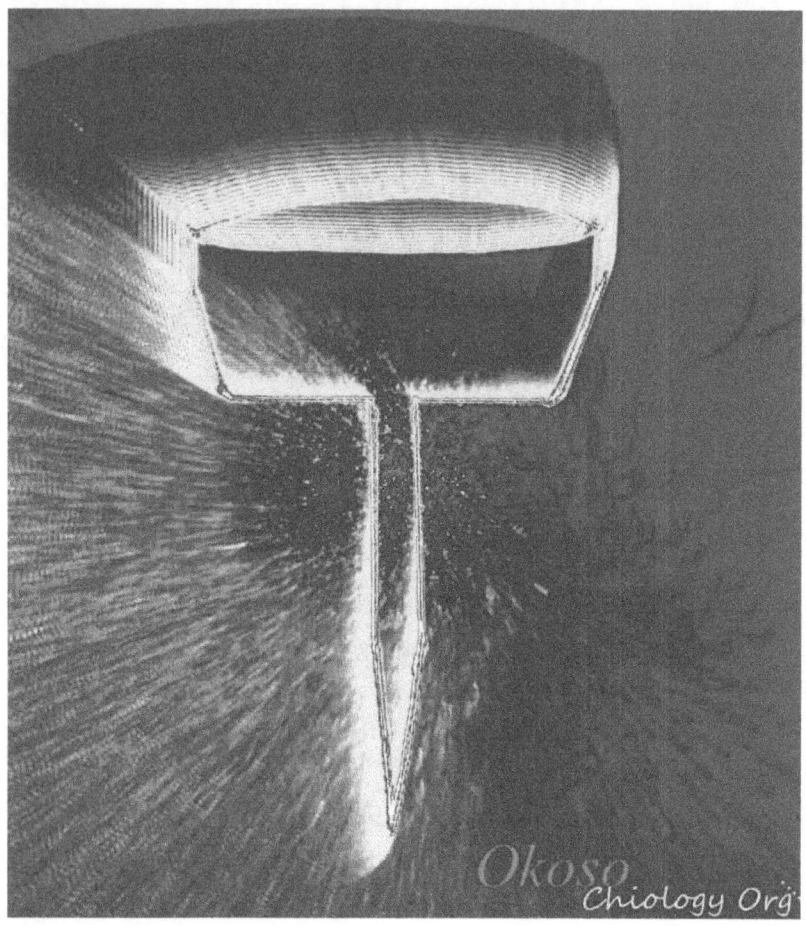

Okoso-Image by the Wizard.

Summary

Words are just communication tools. One should communicate freely without fear. It is important to listen with the mouth when others are speaking, and also it is important to listen to what we are saying.

Igbo voices: advancing the Chi

> Romance is like the Okoso: you just have to follow, and then be ready to communicate at the right moment. The Okoso is like a dancing energetic woman who says; "wait, follow me, then draw me to you".

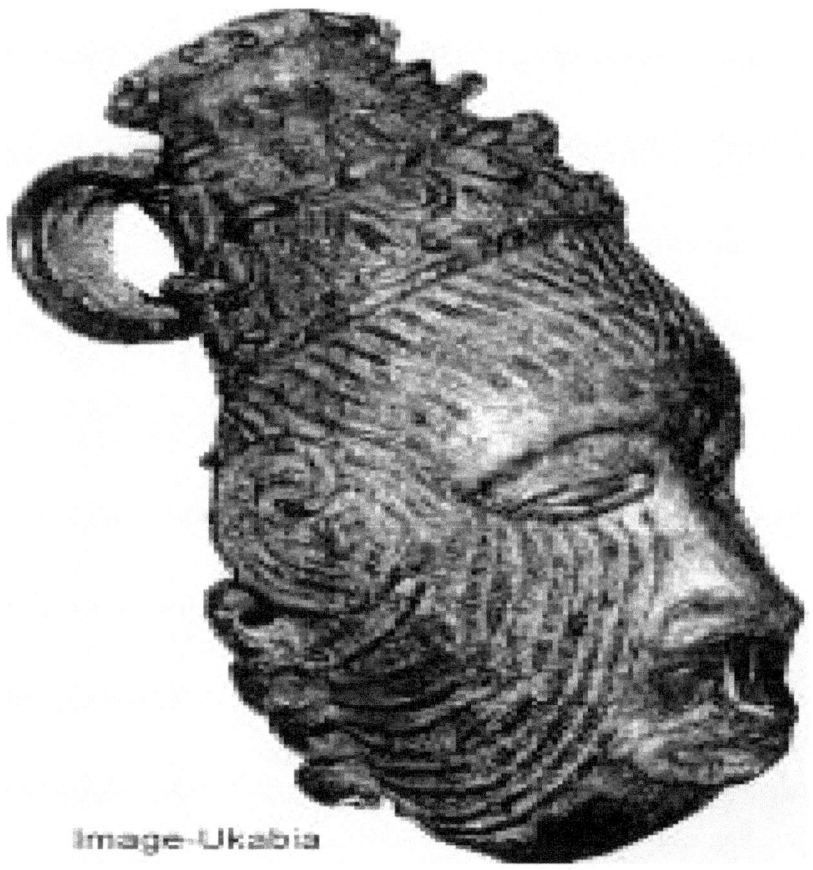

Image-Ukabia

This pendant from an archeological dig from Igbo-ukwu shows the mouth in a communicative gesture. The facial scarification is known as 'Igbu Ichi' and is associated with eminent persons in the community. Objects from the archeological dig have been dated to about 9th century, A.D.

Igbo voices: advancing the Chi

Chapter 8 Laughter

In Igbo, laughter is known as 'ichi ọchi'. 'Ichi ọchi' contains the verb 'chi' which is to 'grab', 'get' or 'lead'. This 'chi' is slightly phonologically different from Chi (personal god/energy summary). However, both are related because the Chi (energy summary) of a person is their 'lead' or what creates a person's life. This is why the Chi is widely regarded as a King (Chibueze).

Basically, 'ichi ọchi'(laughter) is to 'grab and grab', 'get and get' or 'lead and lead'. When you 'grab' or 'get' an item, you are 'leading' that item. When you grab some chocolate and put it in your mouth, you just 'led' the chocolate into your mouth.

We laugh when we grab or get something. For example, if we were terrorized by an indestructible Goliath and one day we suddenly watch Goliath slain by a David: we could break into laughter. We 'get' that no man is indestructible. The ingenious thing about laughter is that we can 'control' or 'lead' what we laugh at. In Chiology, you gain control of a situation by laughing at it. So if you are jobless or friendless, you should laugh at the situation to 'control' or 'lead' it.

Whoever said that laughter is the best medicine is absolutely right. Laughter is healing because it helps us get what we want-healing and wellness. Recently, laughter is being promoted in social medial as able to ameliorate depression and similar emotional conditions. Some clinical studies show that interventional laughter may have beneficial effects on mood. In Advanced Chiology, laughter is recommended whenever possible. If you are broke, laugh at your condition-it is laughable because many people make money easily and you can't. If you are addicted to alcohol, laugh at the idea that you are hooked while

many people just have the amount of alcohol they can tolerate. If you are single, laugh at your situation because being married is one of the easiest things in the world. If you are living in a small house, laugh because there are many mansions undergoing foreclosure because no one wants them. If you are worried, laugh because you already know you should not be worried because there's the Big Chi that is always with us.

Laughter gives insight and wisdom and helps stabilize the emotions that allow us to take the necessary action to be in the life of our choice.

Summary: Laughter is a great medicine and helps us control the situations in our lives. Some clinical studies show that laughter has promise in the management of mood disorders and similar conditions.

Chapter 9 Embrace Action

The Igbo word for breath is 'ume'. 'Ume' is also the word for energy. Radiant energy from the sun is absorbed by leaves of trees, and oxygen is released into the atmosphere in exchange. When we inhale oxygen, it is converted into energy in the cell mitochondria. Without energy production, the human body rapidly dies. Energy derived from oxygen metabolism is used to sustain the body. This energy also enables a person carry out actions in the physical universe.

Basically, we are all here to perform certain actions. For example, one of the actions I am performing right now in addition to maintaining the body is thinking and typing. The word for breath and energy 'ume' contains the verb 'me' which is 'act'. So breathing is intended for action. In the Earth Breathing CD, 'breathe in' is known as 'Embrace Energy' because 'kulu ume' actually means 'carry energy'. However, a CD is in the works to introduce 'breathe in' as 'embrace action'. The word for 'breathe out', kupụ, is from 'embrace out' and is known as 'let go' in the CD.

After months to years of practicing Umeana, an individual gets to the point where they put their breath in what they do. Ideally, while studying you would like to put your breath in the study. While cleaning the house, you would like to put your breath in the action(s) of house cleaning. While making love, it is very important for partners to put their breath in what they are doing.

In essence, whenever possible, while taking a walk or even while eating, one should put their breath in the action(s). Some of the areas of interest an individual could channel their breath include:

- Breathing love

- Breathing harmony
- Breathing success
- Breathing tolerance
- Breathing action
- Breathing peace
- Breathing integrity
- Breathing fortitude
- Breathing equanimity
- Breathing family
- Breathing generosity
- Breathing responsibility
- Breathing authenticity
- Breathing happiness
- Breathing community
- Breathing positivity
- Breathing possibility
- Breathing beauty
- Breathing creativity
- Breathing equality
- Breathing electricity.

It has been validated that breathing practices could alter behavior (Brown, Gerbarg and Muench, 2013) and help eliminate negative emotions such as anger and revenge. For couples, it may be good to practice 'breathing harmony' together or 'breathing peace'. Uncontrolled anger could wreck a relationship.

The Chi determines the actions and destiny of a person. Chidume (Chidi-ume) is a phrase that captures that statement that the 'Chi is energetic' or the 'Chi is energy'. Basically, the Chi is the energy summary of an individual and determines actions and destiny. Success requires action and commitment to action or persistence. Vaseline is a very important and widely used skin product that

was discovered by Robert Chesebrough. He received a patent for the product in 1872, but had a hard time selling his product to pharmacies. Chesebrough had to burn himself with acid and flame in front of audiences, and then cover the wounds with Vaseline while showing old healed wounds in order to convince people of the efficacy of the product. Even that wasn't enough; he had to give out free samples. His commitment and persistence eventually paid off when pharmacies started ordering his product. Vaseline is still widely used around the world today.

Summary

The body requires oxygen to make energy in the mitochondria. Without oxygen, energy production shuts down very rapidly and death ensues. Every human 'embraces energy' through breathing. The word 'breathe in' is also 'embrace energy' or 'embrace action'. In Advanced Chiology, individuals endeavor to breathe into their actions. An individual seeking harmony could learn how to breathe harmony. The Chi is the energy summary of a person. To succeed an individual needs to embrace and commit to action.

Igbo voices: advancing the Chi

Chapter 10 Touch

Touch is known as metụ. Metụ has two components 'me' and 'tụ'. The verb 'me' refers to 'make' and the verb 'tụ' is to 'catch', 'charm', or 'magnetize'. 'Tụ' is also used in the word for vagina (ọtụ)-the vagina is 'charming'. Touch (metụ) is to 'make charm' or simply to 'charm'.

Touching in Chiology has two components-physical and non-physical. In non-physical touching, words are used to create a picture or scenario that 'touches' a person and makes them more willing to act in a certain direction. For example, Chiology intends to create an organization with millions of followers world-wide. In addition, Chiology plans to open 'Churches' where people can 'breathe and move'. It will be an avenue to bring people together, so that we perform less destructive acts such as wars. The intention is to bring to life an ancient principle called Anọjulu. The verb 'nọ' represents the notion of 'togetherness'. The verb 'nọ' is used in the word for home (ụnọ) and welcome (nnọọ) because a home, and welcoming someone, is a promotion of 'togetherness'. A house is only a home, if it is welcoming and promoting togetherness. Ideally, people buy homes that help bring family and friends together. Anọjulu has two main components- a-nọ(togetherness) and julu (full, abundant). Anọjulu is the principle of 'abundance of togetherness'. The 'a' before 'nọ' is a neutral prefix. (For a list of Igbo prefixes and suffixes, please find the book; 'Igbo voices; hidden wisdom from an ancient language' or 'Chi, and healing words from an ancient language').

Basically, non-physical touching involves communicating an idea that is moving and inspiring. This is usually a concept or idea that will enrich the Chi of a person and make it more loving or happier. For example, telling your lover that you are saving

money so that you can go on a holiday in Monte Carlo is inspiring. You could describe a picture of exclusive beaches and magnificent boat trips.

Monaco- image by Katonams.

Physical touch is a way to show affection and 'charm' someone. Lovers, obviously, employ plenty of physical touching to maintain and promote relationships. The art of touching is a very complex process, but in Advanced Chiology you are expected to have a highly developed 'metụ'(touch, charm) skills. Lovers are expected to spend time practicing 'charming' and 'moving' touch activity. One effective trick is to synchronize breathing with touch activity.

Grossly speaking, in Chiology areas of the body recommended for 'charming' in females is around the cheeks, sides of neck, center of the back of the neck, and the occipital protruberances which is the part of the skull close to the neck at the back. Other areas include around the coccyx (tail bone) and around the iliac spines.

Touching is safest among consenting lovers, however, in some occasions touching a friend is appropriate. It may be appropriate to touch a male or female at the upper back far away from sensual organs. However, caution should be exercised because of the risk of being accused of sexual harassment or sexual assault.

Summary

The concept of physical and non-physical touch is very important because it is designed to 'charm', move and inspire a person. This is done mostly by verbal communication as well as physical touching among lovers.

Chapter 11 Courage

One of the most important ways of being in advanced Chiology is being courageous. This is obtained from the spirit of 'agbala'. 'Agbala' contains the verb 'gbala' which is basically 'run home' or 'run away'. The 'a' is a prefix used to reverse the polarity of a verb, making 'agbala' being 'courageous' or confrontational.

A woman who is courageous is known as an 'agbala nwanyi'. During the Biafran war, courageous women led men into battle and stories about their courage are told till this day.

Fear can be conquered by learning and knowledge. For example, fear of snakes can be conquered by learning about poisonous and non-poisonous snakes. Knowledge about snake habitat and behavior helps an individual have a more rational emotion towards snakes. In addition, practicing Earth Breathing (Umeana) could be helpful in overcoming irrational fears and insecurities.

Maduabuchi (man is not the Chi) and Iloabuchi (the postulate that man is not the Chi) are concepts designed to encourage individuals to resist another person trying to be their Chi. The Chi of a person, in its native state, contains positive emotions such as love and joy. The Chi contains emotions that encourage thoughts and actions that are beneficial to an individual. However, an oppressive person by using abusive words and harsh control methods can cause a person to become fearful, sad, angry, frustrated and depressed. Reciting and breathing into the concept that 'another man is not the Chi' is a way to encourage having more and more courage.

In Igbo, laziness is known as 'Ngana'. 'Ngana contains the verb 'Nga' (place) and 'na' (go home or away). A lazy person cannot stand their ground and is always eager to go home or to

someplace where there is no work or activity. A lazy person is at home while others are working because they cannot stand the 'heat' in the work place.

To be courageous is to keep working despite possible danger. A lazy person will run away from the farm saying he/she saw a snake. Lazy people would refuse to work citing that white people are racist. In Advanced Chiology, you are expected to make a list of all the places you have run away from, and if necessary, one can go back to work. Some people run away from Facebook, giving one flimsy excuse after another. In Advanced Chiology, it is a sign of Ngana (laziness, running away from places). Lack of knowledge and purpose is often the reason an individual withdraws from work or community places. The areas a person runs away from, or people a person runs away from, could be considered an individual's edge. These edges are field restrictions and include objects, places, people etc. The spirit of agbala (courage) is helpful in confronting the edges. A courageous person has edges that are wide and far. Someone who lives in New York who is thinking of starting a business in Beijing is definitely courageous and has edges that are quite wide. The Ikenga was introduced to help an individual stand their ground in their chosen profession.

Summary

Courage is very important in Advanced Chiology. Earth Breathing and Sky Breathing are helpful. Knowledge is also very important, in addition to ensuring that one is living a life in which another person is not their Chi.

Chapter 12 Dignity and Protection

The verb 'gwu' is used in the words for dignity (ugwu), hill (ugwu) and dance (egwu). Dignity (ugwu) and hill (ugwu) contain the same prefix 'u' which is more 'aggressive' in 'hill' than in 'dignity'. The verb 'gwu' is used in 'i gwu ji' (protecting a yam-through digging motions that create a mound) and suggests protection. A hill (ugwu) is protective. In historic times, God was often sought on hills because God is protective (Psalm 121, 1). The Hill protected communities from adverse weather such as hurricanes, storms, floods, and from invading armies. During Super storm Sandy that devastated New York, parts of Greater New York that were surrounded by hills were spared. Dance (egwu) is a social behavior with medical implications because as a form of exercise it is protective to the body against stress (and other negative emotions) and could ameliorate high blood pressure, Diabetes Mellitus, Syndrome X, Syndrome X, Y and Z, and facilitate weight loss.

Dignity is very important for any human being. To have dignity is to have protection, self-sufficiency and reserves. One of the ways to acquire dignity is to look inwards into the true self. It starts with examining ones emotions. The emotions are known to affect the quality of thoughts, and thoughts are known to predict our actions.

People who act without dignity tend to display thoughtless actions. Some of the thoughts that precede these actions are "I am not good enough", "I am worthless", or " I am a nobody". These thoughts have underlying negative emotions behind them such as the feeling of worthlessness.

One important way to preserve dignity is to become aware of one's emotions. Negative emotions such as anger, frustration, jealousy, hatred, wickedness etc are some of the emotions that lead to thoughtless acts that can rob us of our dignity. On the other hand, happiness, joy, peace are some of the positive emotions that lead to the right thoughts that keep us focused on our goals and help us preserve human dignity. A dignified human acts rationally and thoughtfully, even in the most challenging situations.

For example, suicide is a thoughtless act that suggests cowardice rather than dignity. An affordable way to improve one's dignity is through Voluntarily Regulated Breathing Practices (VRBPs). VRBPs such as Coherent Breathing can quickly induce a calm and alert state, and ameliorate depression, anger, aggression, post-traumatic stress disorder, while improving emotion regulation, attention, cognitive function and the ability to connect to others (Brown and Gerbarg, 2012). VRBPs also activate the healing, anti-inflammatory, and energy restorative systems of the body by stimulating the activity of the parasympathetic nervous system as well as by balancing the stress response systems (Brown, Gerbarg, and Muench 2013).

Healing breath practices that are augmented with physical activity such as postural movements or dance yield the best results. These activities allow individuals to acquire and maintain positive emotions such as love, happiness, and peace which lead to acts of dignity.

A dignified person is important in the community because they have some reserve that can be called upon in challenging times.

Igbo voices: advancing the Chi

Summary

Dignity starts with self examination that enables an individual to know himself. Breathing relaxation helps an individual acquire positive emotions that lead to the right thoughts and actions. A Dignified person is rational, and acts in a way that is preservative.

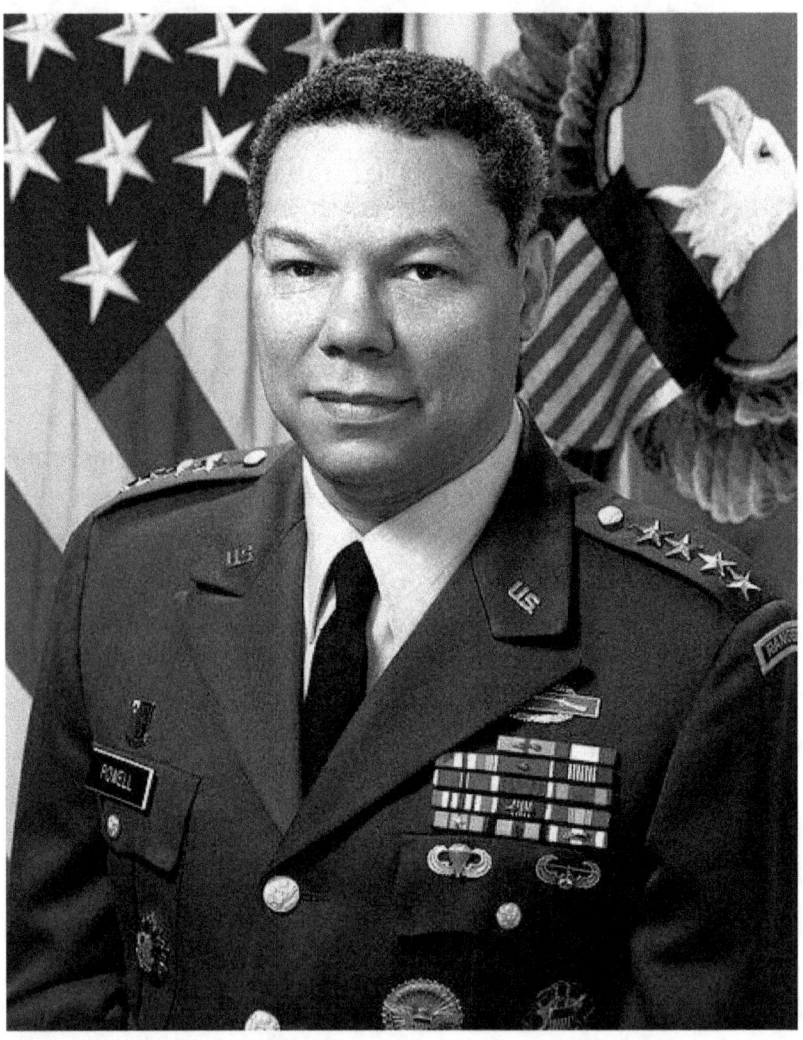

Dignified Individual- Gen. Colin Powell, US four-star General.

Chapter 13 Saying No

Every Chi has a mission to accomplish on the planet earth. The mission could be being peaceful and setting an example of how to have fun here on earth. For others, it could be to help a group of people achieve justice the way the Rev. Dr. Martin Luther King lived.

Whatever, an individual's goals, there would be distractions and obstructions and it is very important to learn how to say no to these. A person's goal is like a canoe going down the Niger River from one location to another. On the way, there would be other obstructing canoes or boats, people shouting on shore for you to pick them up, or maybe people throwing stones. The idea is to say no to these distractions and keep paddling towards the destination.

Loss is a major tragedy, especially, the loss of a loved one from death. Some people struggle to move on after the death of a loved one. It is quite understandable, especially if the person was very good and productive. However, the Igbo people look down upon a house-fly (Ijiji) that stupidly follows a coffin into the grave. After the death of a loved one, some are unable to move on in life and could enter into an extended grieving period. Grief is an emotion that is obviously not good for the Chi. A grieving person who is excessively preoccupied with loss may devote less time in achieving their goals and objectives. Such a person is pre-occupied with a past negative event that may be unhelpful in the future. The idea is to say no to such persistent negativity. Igbo has a grieving period that lasts for weeks called 'ụjụ' that allows a person to mentally adapt to the loss by saying 'no' to negativity.

Igbo voices: advancing the Chi

A goal is like a boat going down a river that needs to be repeatedly paddled forward.

During the 'ụjụ' process, friends and family often ask the mourner(s) about the events leading to the death, and the circumstances of the death. These repeated sympathetic and

empathetic questioning allows the mourner to explore the circumstances of the death, and life changing wisdom could be gained. The process lasts for weeks, so the whole village would have the opportunity to talk to the bereaved, and this facilitates healing and exchange of ideas.

In the modern world, a trained Chiologist uses special techniques that explore the emotions surrounding the death of a loved one to help relieve the grief associated with death and loss. Mourners are encouraged to move and dance. Dancing is part of the burial custom in Igbo land. 'Earthing' a person with 'Earth Breathing' is obviously helpful. After death, life must go on, so the sooner a person gets back to normal the better.

Other individuals may say no to the goals and objectives of a person's Chi. This is a very normal occurrence. Life is not a bed of roses without thorns. Lions have to 'fight' for their food, often risking the sharp and deadly horns of the Sable Antelope. Fortunately, receiving a 'no' reply, is not deadly. In Chiology, one is encouraged to get a partner (e.g. husband, wife, or friend) and practice asking them for something, and they keep saying 'no'. This can be done over and over again, so that a person can lose the fear of 'no'. A 'no' reply does not necessarily mean, that it could not become a 'yes', seconds later. This exercise helps a Chi become unstoppable even in the presence of disagreements or 'no's.

Igbo voices: advancing the Chi

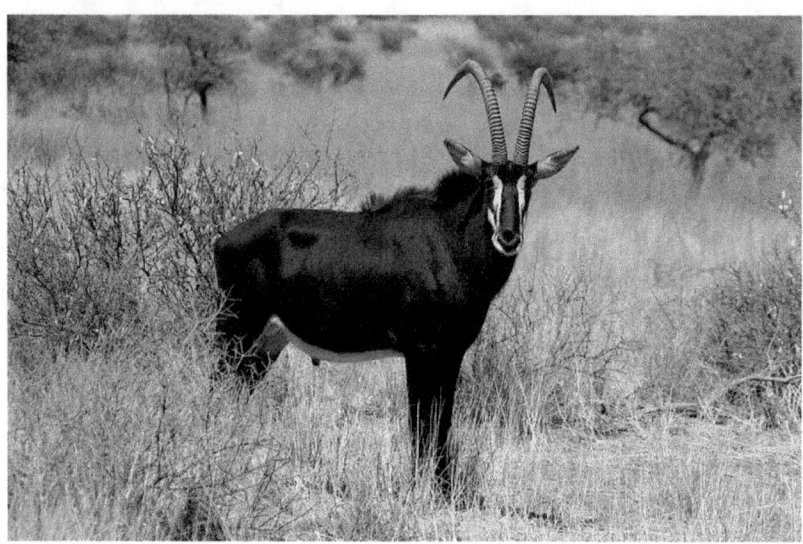

Lions still hunt the Sable antelope despite its sharp and deadly horns. Image by CharlesJSharp

Summary

Each Chi has a goal to accomplish and must say no to distraction. A person must say no to grief and extensive mourning for loss of loved ones or precious physical items such as jewelry. A person knowledgeable about the Chi is not adversely affected by other peoples 'no' to their own objectives.

Chapter 14 Integrity

A proud and boastful person is often liked as well as hated. One sure way to get people to despise you is to be boastful. One possible way to get around being boastful is to actually carry out your boasts. Mohammed Ali did a good job, somewhat, in carrying out his boasts.

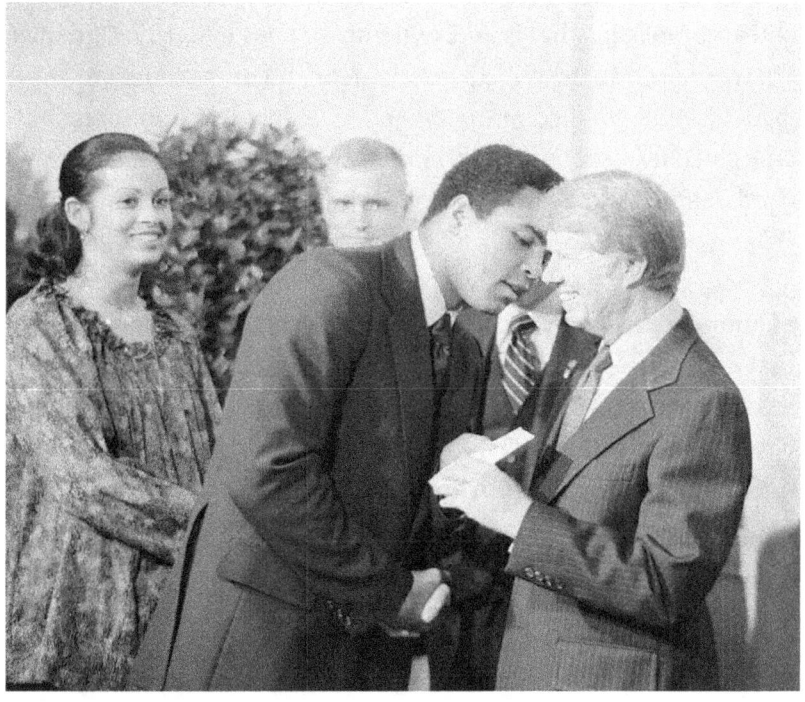

Mohammed Ali with Former President Carter. A person who puts speech to action is an Ekwueme.

Ekwueme is a very important principle of humility. Ekwueme contains the verbs 'kwu' (speak) and 'me' (to do). A person who adopts the spirit of Ekwueme only speaks what they can do. This entails coming from a place that is rooted in humility and reality so one makes achievable statements and postulates.

Igbo voices: advancing the Chi

The ability to do what one says is the basis of integrity. When a person who has integrity says they will be at work at 7.00 am, they are at work at 7.00 am or before 7.00am. If for any reason, they are unable to make it at 7.00am; they communicate the reason for lateness. This ability to communicate situations in which someone is out of integrity is an important part of integrity.

An Engineer who says he can build you a mansion in six months and accomplishes that is an Ekwueme and has integrity. Ogbenye is a word used to describe a poor person. It contains the verb 'ogbe' (section of a community) and 'nye' (give). A poor person is only given by a section of a community or they are rendering goods/services to a small part of the community. To be an Ogbenye is not necessarily a bad thing. Some spiritual assistants are poor because they have dedicated themselves to the service of humanity and only receive from the section of the community that appreciates their work. These individuals often have a high level of integrity. In order to achieve integrity, the spirit of ogbenye may be helpful. In this case, the spirit of ogbenye does not necessarily suggest poverty but rather the humility that entails integrity.

People love to work with someone who has integrity. A Chi that has integrity would likely get a lot of work. Successful goods and services have a high level of integrity. If this book had a low level of integrity you probably won't be reading it at all. Apple is successful in making smart phones because they do what Apple says it does. And every year, Apple works hard to ensure that it's products do what they say it can do better, faster and more reliably.

Igbo voices: advancing the Chi

Summary

Integrity is doing what you said you will do. A person who has integrity is an Ekwueme. It requires the spirit of humility. A person who has integrity gives explanations to situations in which they were unable to keep their word.

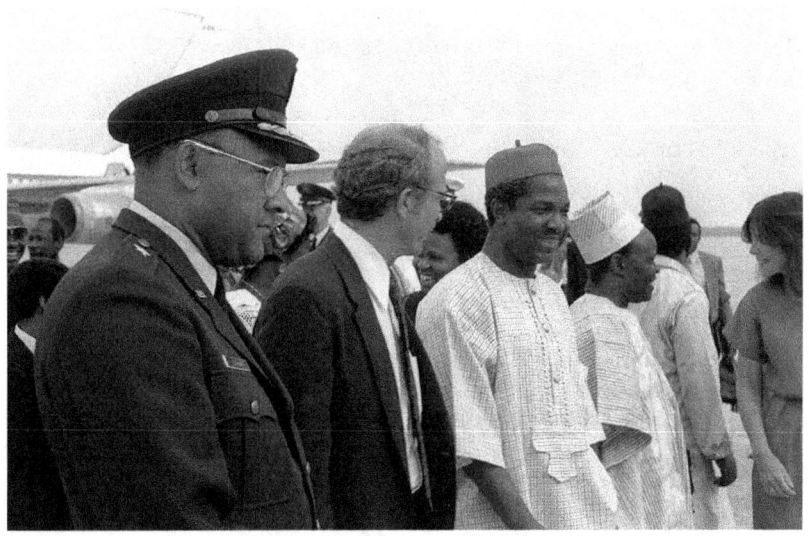

Former Nigerian Vice President Alex Ekwueme (third from left) **on a visit to the US in 1981.**

Igbo voices: advancing the Chi

Chapter 15 Establishment

Unlike the English language, Igbo is primarily made up of verbs, so translating Igbo to English can be challenging. However, there is general agreement that establishment is 'Nkwado'. The modern world is full of establishments such as countries, banks, schools, businesses etc. Establishment can also be used to describe individual activity- a person with a good, reliable job could be considered established.

Nkwado contains the verbs 'kwa' (push, promote) and 'do' (keep), suggesting 'keep pushing'. Basically, every establishment is 'pushing' or 'promoting' something. Citibank, among other things, is 'promoting' credit cards at competitive interest rates.

Citibank promotes credit cards at competitive rates.

The United States Citizenship and Immigration Service (CIS), 'promotes' work permits, Green cards and Citizenship. A person, who works for the CIS should be aware that their goal is to 'keep promoting' work permits, green cards and Citizenships. If the 'promotion' falters or stops, the establishment is headed for collapse. Many businesses fail because of lack of awareness of establishment or lack of awareness of 'promotion'. In Chiology, one of the concepts we are promoting is 'Earth Breathing' or 'Umeana'. In this promotion, one of the things we are 'keeping' is more peaceful human beings.

Igbo voices: advancing the Chi

A person who is established at a job may be 'keeping' money- in other words they are saving money. This person is working so they can 'keep' money. Basically, this person is promoting 'money keeping' or savings. And the person should be clear that one the reason he/she works so hard is the 'promotion' of savings.

The concept of Nkwado also applies to relationships. On Facebook, some individuals who have been married for 20 years often tout their established relationships. Such relationships last so long because the participants 'kept promoting' harmony and balance. They 'kept promoting' respect for one another, and their love for each other.

So it is important for each one of us to ask what we are promoting. If we are angry, sad, depressed, hateful, frustrated or vengeful, that is what we 'keep promoting'. Those emotions are in the Chi, and the results could be disastrous for the mind and body. 'Earthing' oneself by placing and feeling the feet on the ground, and the use of 'Earth Breathing' (Umeana) is helpful in turning these negative emotions into peaceful and loving emotions. Once established on love and happiness, a person can expand the establishment into other ventures.

Summary

The law of establishment is 'keep promoting'. An organization or an individual needs to identify what they are promoting and establishment is continuous promotion. Many adults were told as kids to 'sit down and be quiet' making them very 'quiet'. This is not good for a Chi that has goals and objectives. It might be good for a Chi who wishes to be a security guard but not for someone who wants to make inroads in uncharted territory. The advice here is to 'yell'.

Chapter 16 Solution (Ọ́kpụkpara)

Ọ́kpụkpara is a very important concept in Advanced Chiology. The concept of Ọ́kpụkpara is the key to overcoming problems. In Chiology, a problem is simply a disagreement. That is, there is someone or something that disagrees with your intention. Basically, if you were crossing Central Park in New York City and a leopard starts chasing you; just know that the leopard does not agree that you will walk casually across Central Park unmolested. Pele, the legendary soccer player, faced obstacles each time he took the ball towards defenders. In Igbo, dribbling someone in the soccer game is known as 'ọkpụkpa'. In soccer, to a striker, a defender is an obstacle and the solution is dribbling (ọkpụkpa). Dribbling requires aligning the ball into a space that a defender cannot reach. The alignment is the solution. In ancient Igbo, warriors and 'Generals' often took the name of Ọ́kpụkpara.

A person who has been applying for jobs, without success, has a disagreement between themselves and hiring professionals. The disagreement could be in the contents of the resume or qualifications of an individual, but it is still basically a disagreement. Some employers only hire people they know, so if they don't know you, that's a disagreement.

The source of a family problem could be based on the belief that a given family member is a nobody. So giving away your houses and cars and coming home in tattered clothing would probably resolve many family problems. Some individuals would go to any length to bring a person down only because they were challenged on some subject. It's a problem because the 'challenged' does not agree that they can be challenged. This is why in Igbo, an 'enemy' is known as 'onye ilo mụ' or 'a person of my postulate'. During Apartheid South Africa, the postulate of 'freedom for Africans'

could have you imprisoned, because there are people and systems who had a counter postulate that Africans should remain in bondage.

The first thing you want to look at is the structure of the problem. This is done by looking at the structure of postulates involved. For example, after this book is written, I will make a postulate that it would reach millions of readers. Now we all know that this book could be sitting in a shelf like a fancy mug, if it is not marketed. If people's attentions are not grabbed through direct marketing or through word of mouth, the goal would probably not be achieved. The problem is that people's attention would be seized by other issues or by boredom. Those 'other issues' are the opposing force that creates the problem.

The word 'ọkpụkpara' was coined from 'ọkpụ' (mould, knot, difficulty) and 'kpara'(swing or scatter). In Advanced Chiology, a problem is overcome by untwisting. It is like untwisting a knot in order to ensure an alignment of postulates. This can only be done after a careful study of the structure of the antagonistic postulates that represents a problem. Indeed, a problem is no longer a problem once its structure has been determined.

Sometimes a person who has been killing himself trying to get a job in a corporation, may after studying corporations, now decide to start a corporation. He wasn't able to align to the corporations he/she sought but could create a corporation that aligns with his/her purpose. A person who has been struggling to integrate into a certain family, might as well start a new family.

Igbo voices: advancing the Chi

Summary

Ọkpụkpara is the solution to problems. A problem is a disagreement or opposition of postulates. In order to solve a problem, the basic structure of the opposing postulates has to be determined. After that, effort could be made to realign the postulates.

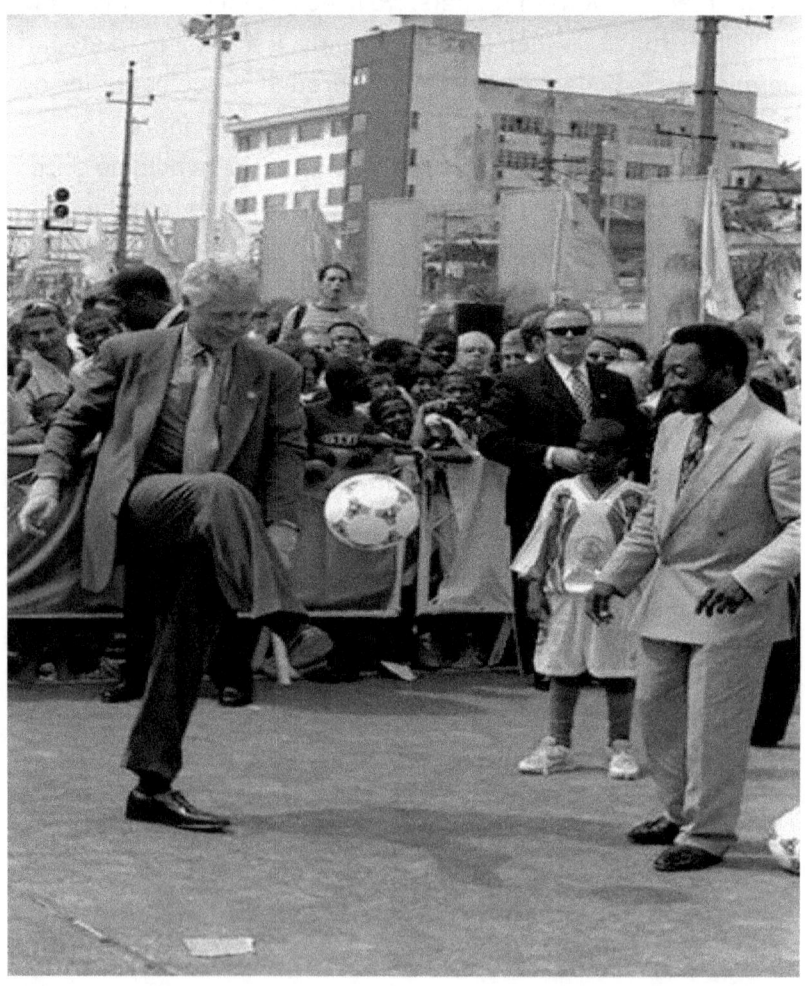

President Clinton and the Legendary Pelé. Dribbling is 'ọkpụkpa'.

Igbo voices: advancing the Chi

Chapter 17 Peace

Peace is known as 'udo' which is from the verb 'do' that communicates 'keeping'. A person who is at peace is well kept.

Every person has a spirit called 'mm**ụọ**'. That spirit resides in the body (arụ) as the soul (**mụ**). A person is a soul, and the soul is housed in the body (arụ **mụ**). Each soul has a Chi, which is the internal summary of the person or a 'personal god'. The Chi determines the thoughts, actions and destiny of a person. If the Chi is in a good state, a person has a favorable outcome. In its native state, the Chi is peaceful and is known as Udochi (Peaceful Chi). A person who is well kept has Udochi or peaceful Chi.

Now, if you have a wife who is always angry, spiteful and always nagging, I would like you to consider the possibility that she is not well kept. She is not at peace. She is not in her native state. This is a native state that can be re-assumed and which the world cannot give. This native state has nothing to do with money or the state of a person's earthly possessions or if a person has a job or not.

The first step is realizing that an individual is a soul (mụ and chi) and the native state is peaceful. Earth breathing (Umeana) and Sky Breathing (Umeigwe) are extremely helpful in achieving this state. However, constant practice of about 20 minutes per day is required. A peaceful person has their breath in their actions and do not engage in actions that can disrupt peace.

A house-hold Ọfọ is a symbol that encourages fairness, balance and harmony within families. Peace cannot be maintained in the absence of harmony.

Igbo voices: advancing the Chi

Peace is inherently tied to prosperity. Although, some nations prosper during wars because of increased arms production, it should be considered false prosperity because arms do not necessarily add value to human life. True prosperity comes in times of peace. In Igbo peace comes from 'Obi ufo' (peaceful heart) and is one of the spirits of the Big Chi. Having a peaceful heart enables an individual connect to many peaceful hearts in the community.

One of the enemies of peace is revenge. Revenge is a negative emotion that yields a useless action because it diverts attention from an individual's original purpose. Revenge is also often mixed with other negative emotions such as recklessness, anger, grief, loss, and sadness.

Revenge is known as mbọ or mbọlu (revenge making). Mbọ is from the verb 'bọ' which is the action 'dig'. In Igbo, we revenge by going back to work to dig (Igbo was an agricultural society). Even after the brutal Biafran war, Igbos have not revenged in a retaliatory sense. During the war, Igbos died in the millions, many starved to death, and pot bellied children with Kwashiokor were common sight in many communities. Despite the injustice, Igbos have shied away from retaliation because revenge in Igbo is 'digging' or 'working'. This explains why, immediately after the war, many Igbos fanned out to different parts of Nigeria where they could enjoy their work. Those who worked in the business sector, relentlessly pursued their businesses and are land owners in many other parts of Nigeria.

Had Igbos revenged, there could have been another war and the prosperity Igbos enjoy today would not have taken a foot hold.

Summary

In Advanced Chiology, peace is in the Chi as 'Udochi' and is obtained by having 'obi ufo' and by concentrating on an individuals' work purpose. Peace inherently brings prosperity. It is important to avoid acts of revenge.

Chapter 18 Create a way (Kezọ)

The knife is known as 'mma'. 'Mma' contains the verb 'ma' which is 'to know'. A knife leads to knowledge. Use a knife to peel an orange and in a while you will become proficient in peeling oranges. Use a knife to cut grass and you will become proficient in grass cutting. An individual who can cut grass and other shrubs can create a way. A way is a connection from one place to another and allows for movement of goods and services. A way saves time and lives by removing obstruction and danger.

A knife could be used to clear land in order to create a farm. A farm is a 'way' to food production. The word for farm 'ugbo' contains the verb 'gbo' which is 'prevention'. Farming is a way to prevent hunger and food scarcity. A job is a 'way' to get money. Giving is a 'way' to obtain 'satisfaction'. And for some, gambling is a way of making money. For others, attending Church services is a 'way' to make friends. In ancient times, the knife was critical for professionals: farmers, wine tappers, fishermen and even the traditional doctor. A professional with a knife has knowledge and a way to make a living.

In Advanced Chiology, participants are expected to review the ways they have created. Each way, has to be maintained. Strategy has to be implemented to prevent weeds and shrubs from over growing the way. An important way to keep a way open is to use it frequently. This is why the word for way 'ụzọ' is derived from the verb 'zọ' which means 'step'. Stepping on a road keeps the road open and enhances knowledge of the road.

Once, we have identified the 'ways' in our lives, we could work on expanding them. The same 'knife' that was used in creating a way

is also useful in expanding the way. The knife is used to remove obstacles.

The 'knife' of life is knowledge. Knowledge of accounting is the 'knife' that can create a way to make a decent amount of money.

Summary

Life is not possible without the ways we create. A knife is necessary for 'way' creation. The knife represents knowledge.

Knowledge helps us create the ways to live our lives.

Chapter 19 Power, Strengths

The Igbo have the Ikenga which is a wooden sculpture that commonly depicts a man in the sitting position. The Ikenga of a 'head hunter' or warrior shows a sitting figure with a sword in one hand and a skull in the other hand. The Igbo tribe is on a rare list of communities that practiced head-hunting. For a hunter, the Ikenga could depict animals being hunted.

The word Ikenga was coined from 'Ike' (power, strength) and 'nga' (place). Basically, the Ikenga is a place of strength. It is a symbol or structure that one goes to in order to acquire strength. This is because the Ikenga normally contains a visual description of a persons' profession. One is paying attention to their profession when they are paying attention to their Ikenga.

Symbolically, Kola nuts and Palm wine are placed next to the Ikenga. Kola nut contains caffeine and is a stimulant like coffee. Palm wine is an alcoholic beverage that can be used for entertainment. Kola-nut and Palm wine are used at the appropriate time to enable a person function professionally and for entertainment after the job is done.

'Nga' the word for place, in Ikenga, contains the verb 'ga' which refers to 'go' or 'going'. This is because a place is where someone 'goes' to. So an Ikenga is not just a 'place of strength', it is also a place you go to for 'going strong'.

Igbo voices: advancing the Chi

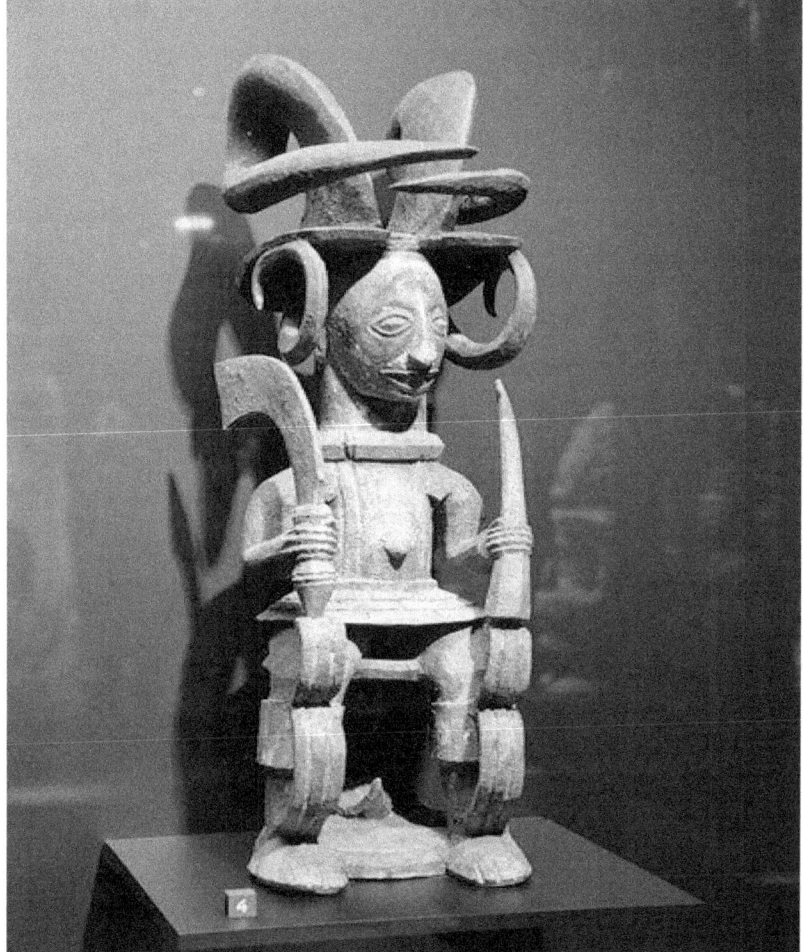

Ikenga-the horns (Mpi) represent strength.

This is why the Ikenga has been associated with success, achievement and time. The Ikenga is also related to the Chi of a person because the Chi determines success in any given profession. The Chi of a warrior contains courage and aggression. The Ikenga is made in a manner that captures the emotions associated with the profession of a person.

A strengths board is a modern Ikenga. It shows the person, their profession and aspirations. In the modern world, coffee (or tea)

and wine can be placed next to the Strengths Board which is normally framed like a photograph. Many people report that coffee or tea helps them carry out their daily assignments. There are some studies that show that coffee and tea contain anti-oxidants that may be helpful to the body. Black and green tea may also contain ingredients that could be helpful in achieving target weight.

Red wine is believed to contribute to longevity, and if used moderately can rapidly bring a couple into intimacy. A healthy and intimate relationship is very good for the mind, soul and body.

Summary

The Ikenga or Strengths board is a success and achievement device. By skillfully using coffee (tea or both) and wine, an individual could better handle their professional and intimate relationships. It is worth noting, that excessive alcohol intake could mar an individual's ability to engage in healthy sexual activity. Also excessive use of coffee may cause insomnia, which can hamper an individual's ability to maintain intimate and professional relationships.

Igbo voices: advancing the Chi

Strengths board of an actor who wishes to live in Hollywood and win an Oscar. Prescription; admire after coffee and after wine, as often as necessary.

Conclusion

The Chi is the 'personal god' of an individual. It is the summary of the energy of a person. Negative energy such as anger, revenge, hatred, depression may lead to misfortune. Happiness and love are the right emotions that lead to a worthy life.

The Chi determines the destiny, end or future of an individual. The destiny of an individual is initiated by their desires or Nchọ. The desires then activate the thoughts that lead to actions. Negative desires activate negative thoughts. Earth breathing (umeana) is a gentle type of breathing that leads to the right emotions that promote the right desires. A person with 'umeana' is very desirable and operates with a lot of integrity.

The Ọfọ is symbol of authority and represents a commitment to truth, justice and law. Justice is fairness, and fairness creates harmony. The Ọfọ is a constant reminder that fairness in the Chi is important in creating a desirable life that is in harmony with others. A person with an Ọfọ practices fairness in their personal and work relationships.

The Ikenga is a 'place of strength' and helps a professional achieve success in their chose profession through focus. The Ikenga is a form of representation of the Chi or destiny of a person because it represents a person's chosen profession and/or hobbies. The Strengths board is a modern Ikenga.

Igbo voices: advancing the Chi

The End

Igbo will always be around (Igbo ga adi)

BIBLIOGRAPHY

1. Achebe, Chinua. Things Fall Apart. Anchor Books -- Doubleday, NYC (January 1, 1994)
2. Achebe, Chinua. No Longer at Ease. Heinemann, 1960.
3. Achebe, Chinua. Arrow of God. Heinemann, 1964.
4. Achebe, Chinua. There was a country: a personal history of Biafra. © 2013 Penguin.
5. Aguwa, Jude C. U. (1995). The Agwu deity in Igbo religion. Fourth Dimension Publishing Co., Ltd. ISBN 978-156-399-0.
6. Anunobi, Chikodili. Nri Warriors of Peace. Zenith Press; 1 edition (February 28, 2006)
7. Arecaceae - Università di Catania http://www.dipbot.unict.it/palms/Arec_fam.html
8. Arecaceae - University of Hawaii Botany http://www.botany.hawaii.edu/faculty/carr/arec.htm
9. Arecaceae in Flora of North America http://www.efloras.org/florataxon.aspx?flora_id=1&taxon_id=10061
10. Basden, George Thomas (1921). Among the Ibos of Nigeria. Nonsuch Publishing
11. Botha, R. and C. Knight (eds) 2009. The Cradle of Language. Oxford: Oxford University Press.
12. Brown, RP and Gerbarg, P. The Healing Power of the breath. 2012 Shambhala publications.
13. Brown RP, Gerbarg PL, Muench F Breathing practices for treatment of psychiatric and stress-related medical conditions.Psychiatr Clin North Am. 2013

14. Catholic Encyclopedia: Palm in Christian Symbolism http://www.newadvent.org/cathen/11432a.htm

15. Date Sex @ University of Pennsylvania Museum of Archaeology and Anthropology. http://www.penn.museum/

16. Davidson, R and Begley S. The emotional life of your brain: How its unique patterns affect the way you think, feel and live-and how you can change them. © 2012 Plume.

17. Dolgoff-Kasper, Baldwin A, Johnson S, Edling N, Sethi GK. Effect of laughter on mood and heart rate variability in patients awaiting organ transplantation: a pilot study. Altern Ther Health Med. 2012 Jul-Aug; 18 (4): 53-8.

18. Dollar, Creflo. Experiencing God's Love. A guide for new believers. Creflo Dollar Ministries ISBN 1-59089-806-0.

19. Ejizu, Christopher. Ofo; Igbo ritual and symbol. Fourth Dimension Publishing Co. (March 11, 2002).

20. Frantzis, Bruce Kumar. The Chi Revolution: Harnessing the Healing Power of Your Life Force. Blue Snake Books. ISBN 1-58394-193-2.

21. Frey Bruno S Happy People Live Longer, , Science 4 February 2011: 542-543.

22. Gallup. State of the American Workplace Report 2013.

23. Gerber M[1], Brand S, Elliot C, Holsboer-Trachsler E, Pühse U Aerobic Exercise, Ball Sports, Dancing, and weight lifting as moderators of the relationship between stress and depressive symptoms: an exploratory cross-sectional study with Swiss University Students. Percept Mot Skills. 2014 Dec;119(3):679-697.

24. Holt, Stephen. Combat Syndrom X, Y, Z. Wellness publishing (2002).
25. Holt, Stephen. A certification program for dietary supplement councilors. Holt Institute of Medicine press © 2008. www.hiom.org
26. Holt, Stephen. The definitive guide to colon hydrotherapy: Principles and Practice of Colonic Irrigation. © 2013 Holt Institute of Medicine.
27. Holt, Stephen. Sleep naturally. © 2003 Wellness publishing.
28. Holt, Stephen. Sex the natural way.(c) 2011 Holt Institute of Medicine.
29. http://en.wikipedia.org/wiki/Shalom
30. Ilogu, Edmund (1974). Christianity and Ibo culture. Brill. ISBN 90-04-04021-8
31. Isichei, Elizabeth Allo (1997). A History of African Societies to 1870. Cambridge University Press. p. 247. ISBN 0-521-45599-5.
32. Kong M, Shin SH, Lee E, Yun EK. The effect of laughter therapy on radiation dermatitis in patients with breast cancer: a single-blind prospective pilot study. Onco Targets Ther. 2014 Nov 4;7:2053-9. doi: 10.2147/OTT.S72973. eCollection 2014.
33. Landscaping with Palms in the Mediterranean. http://www.palms.org/palmsjournal/2001/landscaping.htm
34. Lindsay, David (2000). *House of invention : the secret life of everyday products*. New York, N.Y.: Lyons Press. p. 20-21
35. Murrock CJ[1], Graor CH. Effects of dance on depression, physical function, and disability in underserved adults. J Aging Phys Act. 2014 Jul;22(3):380-5. doi: 10.1123/japa.2013-0003. Epub 2013 Aug 12.

36. Nwafor, Chukwukadibia. Leopards of the Magical dawn.(c) 2014 lulu.com
37. Nwosu, Uzoma. Igbo voices; hidden wisdom from an ancient language. © 2013
38. Nwosu, Uzoma. Chi, and healing words from an ancient language. © 2013
39. Nwosu, Uzoma. The Chiology way to happiness. © 2014.
40. Ogomaka, P.M.C, (in press), 'Number Systems including some Indigenous Number Systems'. Teaching Modules for Secondary School Teachers of General Mathematics, Abuja: NMC
41. Ogomaka, P.M.C. & Akukwe, A.C., 1998, 'School and Work place Mathematics in Imo State: Some implications', Nigerian Journal of Curriculum and Instruction, Vol. 7, No 1:13-18
42. Ohuche, R.O, Ezeilo, J.O.C; Eke, B. I, et al., 1986, Everyday Mathematics for the Junior Secondary School, Book 1, Enugu: Fourth Dimension Publishers.
43. Ojike, Mbonu, My Africa, 1946.
44. Olaudah Equiano, The Interesting Narrative of the Life of Olaudah Equiano, or Gustavus Vassa, the African. Simon & Brown publishers.
45. Onwuejeogwu, M. Angulu (1981). An Igbo civilization: Nri kingdom & hegemony. Ethnographica. ISBN 978-123-105-X.

46. Palm and Cycad Societies of Australia
http://www.pacsoa.org.au/w/index.php?title=Ceroxylon_quindiuense

47. Palms: their conservation and sustained utilization. http://www.iucn.org/

48. Palm Tree Symbolism. http://www.snant.com/
49. Pamela J. W. Gore (1996-01-22). "Phases of the Moon". Georgia Perimeter College. http://facstaff.gpc.edu/~pgore/astronomy/astr101/moonphas.htm
50. Patrick Mathias Chukwuaku Ogomaka. Traditional Igbo Numbering System: A Reconstruction. Africa Development, Vol. XXX, No.3, 2005, pp. 35–47 © Council for the Development of Social Science Research in Africa, 2005 (ISSN 0850-3907)

51. Revolutionary War Exhibit Text - November 2002
52. Salerno, John P. The Salerno Solution. © 2013 Take Charge books.
53. Schwager, E. "From Petroleum Jelly to Riches". *Drug News & Perspectives* **11** (2): p. 127.
54. Streeter CC, Gerbarg PL, Saper MD, Ciraulo DA, and Brown RP. Effects of yoga on the autonomic nervous system, gamma-aminobutyric-acid, and allostasis in epilepsy, depression, and Post-traumatic Stress Disorder. Medical Hypotheses. 2012. May;78(5):571-9.
55. Sylvester Okwunodu Ogbechie,: Ben Enwonwu: the making of an African modernist. University Rochester Press, 2008.
56. The Holy Bible.
57. Tolle, Eckhart. The Power of Now: A Guide to Spiritual Enlighenment. New world library, 2004
58. Tolle, Eckhart. A New Earth. Awakening to your Life's purpose. Penguin, 2008.
59. Uchendu, Victor C. The Igbo of Southeast Nigeria. Van Nostrand Reinhold Company, 1965.
60. Udeani, Chibueze C. (2007). Inculturation as dialogue: Igbo culture and the message of Christ. Rodopi. p. 28—29. ISBN 90-420-2229-9.

61. Tropical Palms by Food and Agriculture Organization http://www.fao.org/documents/show_cdr.asp/en/
62. Uzukwu, E. Elochukwu (1997). Worship as body language: introduction to Christian worship : an African orientation. Liturgical Press. ISBN 0-8146-6151-3.
63. Virtual Palm Encyclopedia - Introduction http://www.plantapalm.com/vpe/introduction/vpe_introduction.htm
64. Virtual Palm Encyclopedia - Evolution and the fossil recordhttp://www.plantapalm.com/vpe/evolution/vpe_evolution.htm
65. Woodbury-Fariña MA, Antongiorgi JL Humor. Psychiatr Clin North Am. 2014 Dec;37(4):561-578. doi: 10.1016/j.psc.2014.08.006. Epub 2014 Nov 25.
66. Zhang X[1], Ni X, Chen P. Study about the effects of different fitness sports on cognitive function and emotion of the aged. Cell Biochem Biophys. 2014 Dec;70(3):1591-6. doi: 10.1007/s12013-014-0100-8.

Books and publications by the Author.

1. Kenneth A. Egol, M.D., Jaspal R. Singh, M.D., and Uzoma Nwosu, M.D. Functional Outcome in Patients Treated for Chronic Posttraumatic Osteomyelitis. Bulletin of the NYU Hospital for Joint Diseases 2009;67(4):313-7.
2. Jaspal Ricky Singh, M.D., Uzoma Nwosu, M.D., and Kenneth A. Egol, M.D. Long-Term Functional Outcome and Donor-Site Morbidity Associated with Autogenous Iliac Crest Bone Grafts Utilizing a Modified Anterior Approach . Bulletin of the NYU Hospital for Joint Diseases 2009;67(4):347-51.
3. Uzoma Nwosu, MD. Igbo voices; hidden wisdom from an ancient language. ©2013
4. Uzoma Nwosu, MD. Chi, and healing words from an ancient language © 2013
5. Stephen Holt MD, Uzoma Nwosu, MD, Clifford Carroll. The Topical Pain Relief Revolution: Principles and Practice of Compounding Pharmacy. © 2013 Holt Institute of Medicine.
6. Uzoma Nwosu, MD. The Chiology way to happiness © 2014.

About the Author

Dr. Uzoma Nwosu is a graduate of College of Medicine, University of Nigeria, Enugu Campus. He worked as a Principal Medical Officer with the department of Health, Johannesburg, South Africa before joining the Pharmaceutical Industry to perform research. Dr. Nwosu also worked as a Research Fellow at the NYU Hospital for Joint Diseases. He is a co-author of peer-reviewed medical papers.

He is keenly interested in African culture, and its impact on human health and development. The decision to write this book was made after reading the book "Nri Warriors of Peace" by Chikodi Anunobi. Subsequently, an analysis of the Igbo word for lungs, 'ngugu' showed it was coined from the verb 'gugu' which means to console. This discovery led to Dr. Richard Brown and his wife Dr. Patricia Garberg, who teach the use of breath in Healing.

This helped validate the many thoughts behind Igbo words and accelerated the development of this book.

Index

Abundance, 33, 35, 36, 39, 53
Action, 13, 19, 49, 50, 51, 52, 65, 74
Adolf Hitler, 23
Alex Ekwueme, 67
Amana, 12, 20
American Revolutionary War, 38
Anger, 12, 21, 23, 29, 30, 51, 59, 74
Angry, 16, 30, 32, 56, 69, 73
Anka, 12
Anti-aging, 12
Anti-clock wise, 26
Apollo, 38
Archeological, 47
Assyrians, 38
Authenticity, 35, 51
Beauty, 35, 51
Being, 11, 12, 27, 39, 40, 43, 48, 55, 56, 58, 61, 65, 78
Biafra, 15, 84
Black, 42, 80
Breath, 84, 91
Breathing, 4, 9, 11, 12, 18, 20, 21, 22, 36, 50, 51, 52, 54, 56
British, 38
Cannon balls, 38
Catherine Acholonu, 7
Cervical Cancer, 9
Charles Thurstan Shaw, 7
Chi, 1, 4, 5, 9, 11, 13, 14, 15, 16, 17, 19, 22, 23, 28, 30, 31, 32, 33, 35, 36, 42, 48, 49, 53, 56, 57, 61, 63, 64, 66, 69, 73, 74, 75, 79, 85, 87, 90
Chidume, 51
Chief Cletus Ibeto, 13
Chief Innocent Chukwuma, 13

Chief Moshood Abiola, 17
Chimanda Adichie, 15
Chinua Achebe, 7, 9, 15, 84
Chiologist, 13, 41, 63
Chiology, 3, 4, 5, 13, 14, 18, 19, 22, 26, 28, 36, 40, 41, 43, 48, 52,
 53, 54, 56, 57, 63, 68, 70, 71, 75, 76, 90
Chloroquine, 9
Christianity, 19, 38, 86
Clive Swersky, 7
Coffee, 78, 79, 80, 81
Combination, 26, 27
Commerce, 13
Communication, 40, 41, 43, 46, 55
Community, 30, 31, 33, 35, 40, 51, 57, 59, 66, 74
Construction, 30, 38, 39
Cosmetics, 38
Courage, 4, 5, 14, 19, 56, 57, 79
Create, 11, 25, 26, 27, 53, 58, 71, 76, 77
Creativity, 21, 35, 51
Death, 11, 21, 52, 61, 62, 63, 74
Decisions, 23, 27, 29
Defiance, 14
Depressed, 56, 69
Desire, 5, 17, 18, 19, 23, 25, 26, 27,
 28, 29,
Destiny, 9, 11, 15, 16, 17, 19, 23, 29, 30, 73
Dignity, 5, 58, 60
Discipline, 20
Dr. Nnamdi Azikiwe, 15
Dyes, 38
Earth, 11, 12, 20, 21, 25, 27, 61
Earth breathing, 5, 11, 12, 18, 20, 21, 23, 27, 29, 30, 31, 36, 39, 41,
 50, 56, 57, 63, 68, 69, 73
Education, 10, 39
Electricity, 35, 51
Emotions, 12, 13, 16, 18, 20, 21, 23, 29, 35, 36, 49, 51, 56, 58, 59,
 60, 63, 69, 74, 79
Energy, 11, 13, 16, 17, 21, 22, 23, 48, 50, 52, 59

Entertainment, 10, 78
Equality, 35, 51
Equanimity, 35, 51
Establishment, 6, 68
Faith, 19
Family, 17, 31, 35, 41, 51, 53, 62, 70, 71
Fashion, 13, 25
Fearful, 56
Fort Moultrie, 38
Fortitude, 35, 41, 51
Frustrated, 56, 69
Frustration, 12, 21, 23, 30, 59
Future, 11, 16, 19, 61
Game, 17, 18, 23, 25, 26, 27, 70
General Aguiyi-Ironsi, 15
Generosity, 35, 51
Genital warts, 9
Gentle, 20, 23, 36
Germany, 23
Glucose, 11
God, 15, 19, 30, 31, 58, 84, 85
Gracefully, 12
Greece, 38
Green tea, 80
Happiness, 9, 16, 20, 35, 51, 59, 69, 90
Happy, 11, 17
Harmony, 33, 51, 52, 69, 73
Head-hunting, 78
Health, 10, 91
Heart, 20, 21, 38, 74, 85
Home, 12, 17, 23, 25, 26, 27, 29, 39, 53, 56, 70
Hospital, 9, 11, 90, 91
House-fly, 61
Human Papilloma Virus, 9
Ibeto Group, 13
Ichi, 47, 48
Igbo, 1, 2, 5, 7, 9, 11, 12, 13, 15, 16, 20, 27, 30, 33, 37, 38, 39, 40,
 42, 48, 50, 53, 56, 61, 63, 68, 70, 74, 78, 83, 84, 85, 87, 88,

90, 91
Igbo voices, 9, 14, 53
Igbo-ukwu, 47
Ikenga, 57, 78, 79, 80
Incense, 38
Innocence, 38, 39
Insecurity, 41
Integrity, 6, 20, 35, 51, 65,
 66, 67
Invalidation, 14
Jesus, 33, 38
Judaism, 38
June 12 Presidential elections, 17
Knowledge, 9, 12, 28, 41, 56, 57, 76, 77
Laughter, 5, 48, 49, 85, 86
Life, 9, 11, 13, 16, 21, 22, 27, 30, 31, 33, 35, 38, 48, 49, 53, 57, 61, 63, 74, 77, 85, 87, 88
Lions, 63, 64
Longevity, 16, 80
Loss, 58, 61, 63, 64, 74
Love, 9, 16, 50, 56, 59, 66, 69
Lungs, 91
Maryland, 11
Mbonu Ojike, 7, 9
Medical, 4, 10, 58, 84, 91
Mitochondria, 11, 21, 50, 52
Money, 13, 48, 54, 69, 73, 76, 77
Mother, 17, 21
Motor vehicle accident, 16
Mouth, 43, 46, 47, 48, 71
Nanka, 12
Negative, 12, 13, 16, 18, 21, 23, 29, 51, 58, 61, 69, 74
New York, 11, 13, 28, 57, 58, 70
New York Police Department, 11
Nigeria, 84, 88, 91
Nigerian, 15, 87
Nnewi, 13
NYPD, 11

Nze, 20
Obi umeana, 20
Ọfọ, 5, 19, 33, 35, 36, 38, 73
Ojike, 12, 13, 19, 30, 33, 87
Okoso, 44, 45, 46
Ọkpụkpara, 6, 70, 72
Opposing coils, 33
Oppressors, 19
Outcomes, 11
Oxygen, 11, 21, 50, 52
Ozo, 20
Palm, 15, 21, 37, 38, 39
Palm Sunday, 38
Palm Tree, 5, 37, 88
Pat Utomi, 15
Patience, 20
Peace, 6, 20, 37, 38, 51, 59, 73, 74, 75, 84, 91
Peaceful, 11, 61, 68, 69, 73, 74
Persist, 13
Persistence, 51
Personal god, 9, 13, 30, 48, 73
Phillip Emeagwali, 15
Planet, 11, 61
Positivity, 35, 51
Possibility, 35, 51, 73
Power, 4, 6, 78, 84, 85, 88
Practical, 26
Prosperity, 10, 74, 75
Protection, 5, 58
Psychiatric, 11
Rat race, 29
Reckless, 23
Recklessness, 16, 74
Rehabilitate, 13, 17, 23, 27
Rehabilitating, 13, 25, 26
Religion, 84
Responsibility, 35, 51
Revenge, 74, 75

Right, 9, 12, 16, 23, 27, 39, 40, 48, 50, 59, 60
Sable Antelope, 63
Sad, 56, 69
Security, 5, 40
Seeds, 17, 25, 26, 27, 37
Service, 20, 66
Sky breathing, 21, 22
Solution, 6, 70, 88
Soul, 16, 19, 73, 80
Spirit, 15, 16, 19, 43, 56, 57, 65, 66, 67, 73
Spiritual, 13, 15, 66
Strengths, 6, 78, 80, 81
Strengths board, 79
Stress, 23, 58, 59, 84
Success, 13, 51, 70, 79, 80
Tea, 79, 80
Textbook, 10
Tolerance, 51
Topical, 9
Touch, 5, 53
Town, 13
Treatment, 4, 9, 84
Umbrella, 39
Umeana, 5, 10, 11, 12, 20, 21, 23, 27, 30, 36, 50, 56, 68, 69, 73
Uprightness, 39
Varnishes, 38
Vengeance, 23, 29
Vengeful, 11, 23, 69
Vigilance, 9
Voluntarily Regulated Breathing Practices, 12, 59
VRBPs, 12, 59
Wart, 9
Way, 85, 86
Wisdom, 19, 20, 49, 53, 63, 87, 90
Wonderful, 11
Work, 8
World, 88

www.ingramcontent.com/pod-product-compliance
Lightning Source LLC
Chambersburg PA
CBHW051735170526
45167CB00002B/950